JAN — 98

ENTERED APR 0 7 1993

Corporate Television Programming

Applications and Techniques

by Eugene Marlow, Ph.D.

Knowledge Industry Publications, Inc.
White Plains, NY

The Video Bookshelf

Corporate Television Programming: Applications and Techniques

384.556 M349c

Marlow, Eugene.

Corporate television
 programming

Library of Congress Cataloging-in-Publication Data

Marlow, Eugene.
 Corporate television programming : applications and techniques / by
Eugene Marlow.
 p. cm. — (The Video bookshelf)
 Includes bibliographical references.
 ISBN 0-86729-312-8 (hc) : $39.95
 1. Industrial television. 2. Television in management. 3. Video record-
ings—Production and direction. I. Title. II. Series.
HD30.34.M37 1992
384.55′6—dc20 92-16573
 CIP

Printed in the United States of America

10 9 8 7 6 5 4 3 2 1

Table of Contents

List of Figures . v

Foreword and Acknowledgements . vii

1. Video: The Next Best Thing to Being There 1

2. General Principles of Video Programming 11

3. Production Principles . 15

4. Sales Training: The First Electrovisual Application 35

5. Electronic Sales and Marketing . 51

6. Skills Training: The Ubiquitous Instructor 71

7. Role Playing: The Electrovisual Mirror 89

8. Management Video: Executives Get into the Act 101

9. Employee Communications: Spreading the Word
 Electronically . 115

10. Employee News: The Electrovisual House Organ 131

11. External Communications: Reaching Out 145

12. A Look Back . . . A Look Ahead . 155

Appendix A: The Electrovisual Manager: A Summary 167

Appendix B: Major Studies of the Corporate Television
Industry. 173

About the Author . 175

List of Figures

Figure 1 Location shoot for a sales and marketing program 64

Figure 2 Studio shoot for a training program 65

Figure 3 Computer video graphics for training 72

Figure 4 Role modeling video in production 91

Figure 5 Studio set for an executive program 113

Figure 6 Videographer/editor finishes a shareholders' program . . 124

Figure 7 Energy information exhibit . 151

Foreword and Acknowledgements

In an episode from a television science fiction series (I believe it was the *Twilight Zone*) a group of scientists turn to a super computer for answers during a major crisis that appears to be leading to a world conflagration.

These scientists are the most knowledgeable in the world. They input all of their knowledge into the computer. They hope that the computer will spew out a set of "answers" or "guidelines" that will lead mankind back from the brink of destruction.

In the final scene, the computer prints out a set of rules: The Ten Commandments.

While this teleplay is part science, part fiction, part reality, part wishful thinking, the concept of a set of rules for everyone to follow that leads to a better life is something every generation seems to need. This human need is the basis of all religion, law, rituals and mores.

Similarly, how many people in the corporate television programming business have wished at some time or other for ready-made answers to a production problem or immediate knowledge of a proven approach to a particular corporate television programming application?

Corporate Television Programming is an attempt to identify and codify guidelines and solutions to corporate television problems and applications.

This book is partly based on my own 20 years of experience in this business, initiated in 1972 when I became an assistant to the producer for a weekly employee news show for Citibank (New York City). This experience (and subsequent work at Prudential Insurance, Newark, NJ, in the mid-1970s) led to a 1976 speech—"Ten Rules for Employee News"—in which I attempted to outline principles that govern the effective and efficient use of videotape for corporate employee news programs.

Together with seven years of television production managerial experience at Union Carbide in the mid-1970s and early 1980s plus 10 years of independent production and consulting work, I have wondered about the other uses of videotape in the corporate communications context, such as sales training, role playing, marketing, general employee communications, public affairs, community relations, press relations and government relations. The question was: Are there general rules that cut across all internal and external corporate television programming applications? And are there specific rules that apply to each application?

Since the mid-1970s I have collected, catalogued and reviewed the statements of corporate television users in close to 600 articles from over 50 American trade and consumer publications published in the last 33 + years, reviewed and analyzed the various corporate television studies published between 1969-1988, and interviewed many colleagues.

It is upon this collective written and anecdotal experience that this book is based.

I am grateful to Ellen Lazer, senior editor at Knowledge Industry Publications, for her deft and incisive editing. My thanks also to the many in-house and free-lance producers whose work and commentary is described in this book. Appreciation also to the countless numbers of television production professionals who have shared their work and insights with me over the years. Let there be no doubt that their experience and expertise is expressed (directly and indirectly) in this volume.

E.M.

1

Video: The Next Best Thing to Being There

VIDEO: A MANAGEMENT TOOL

Life for the executive used to be simpler. A businessperson made a product for one price and sold it at a higher price. He made a profit. Today, however, we talk about product equity, cash flow, management information systems, Equal Employment Opportunity, corporate child-care facilities, product liability, multinational markets, globalization.

There was a time when a top executive could "hide" in the executive suite—from employees, from government agencies, from consumers. No longer. From the outside world are pressures from local, state and Federal government agencies, consumer groups, environmentalists, women's organizations, minority groups, civil rights activists, stock-holder groups. And from inside the corporation are pressures from employees for more information directly from top management about vital concerns on a frequent timetable.

Management has shifted dramatically from a remote environment to an intimate one. There is no doubt corporate executives have their hands full. Corporate executives are faced with the choice of either

1

keeping their heads in the sand, or facing up to another managerial responsibility: communicating with many diverse audiences inside and outside the firm.

Coincident with this change in the content and style of corporate management was the arrival in the mid-1950s of a tool to help management solve its short- and long-range internal and external organizational problems: videotape.

While the history of corporate video goes back to at least 1959 (just three years after the commercial introduction of videotape in 1956), the so-called "breakthrough" in the use of video for corporation communications came in 1971-72 when Sony introduced its first line of 3/4-inch videocassette players. With this technology companies had the means to distribute information in an effective and efficient manner. Today, according to D/J Brush Associates, over 10,000 organizations, large and small, use videotape. It is a $6 billion business.

VIDEO'S FEATURES AND BENEFITS

What makes video so special? What characteristics does it have that make it an effective and efficient corporate communications tool?

Like other new technologies, in its first decade of use video was still perceived by some as a toy. (Film, for example, was initially considered a plaything; in more contemporary times, the initial "public" use of personal computing technology was "video games.")

Today, however, video is widely perceived as a communications tool with several significant benefits.

Geographic Reach

For example, video offers an executive the capability of communicating with geographically dispersed audiences in a vastly efficient, timely and professional manner. Say, for example, a corporation has 40 manufacturing and sales offices. If the president of the company were to try and visit each of these locations in a year's period with a message about the state of the company, the executive would be constantly on the road. And by the time the executive got to location 40, the state of the company would have already changed.

A message on videocassette, however, is a different story. A chief executive can presume that within a relatively short time most personnel specified to view the program will see the program and will have heard the same information from the same person. This does not mean everyone will have the same reaction to the information (even the broadcasters and advertisers haven't figured that one out yet), but, at the very minimum, the executive can be assured the specified audience got the message within the same relative time, and the message was told the way he or she wanted it told.

Does this mean executives don't have to travel anymore? On the contrary, the use of the video medium does not necessarily cut out travel. But it does mean that once the executive gets to a location, he or she may not have to spend precious time on basic information. There is more time to answer questions, to ask questions, to visit, to chat, to observe, to share—to communicate.

The video medium gives the executive more flexibility in terms of reaching audiences within (and without) the company that are not always reachable on a regular basis and in terms of what transpires once the executive does visit a particular location.

Intimacy

Video can be a more "personal" communications medium than, say, a memorandum. As one executive told me, "Video helps me to motivate employees, to increase their productivity." Asked how, the executive replied: "An employee who understands why he or she is doing what he or she is doing has a better opportunity of doing a better job because they have a better understanding of the 'context' in which they're working. Now this means telling them the bad news as well as the good news. It means telling them when they need to do better, and congratulating them when things are good. Sometimes you do both at the same time. But the point is, I have to communicate, that's part of my job. Now, I could visit every location where we have operations, but I would be spending all my time traveling and telling people the same thing over and over again. With video I can get the information out in a personal way, even though I'm not there. Of course, a personal visit is always best, and I don't think anyone would argue that. But when that's not feasible, video is the next best thing."

From my own experience with videos in which top corporate management has appeared, feedback has indicated that these programs (1) helped the viewers understand the goals and missions of the company, (2) helped viewers become more aware of senior management's objectives, (3) made viewers more confident about top management's understanding of the operating problems of the company's various businesses, and (4) helped field managers to do a better job of managing.

Employees generally and middle management in particular want to hear from top management directly as often as possible. Communication via video is always possible. In today's business environment, communication with audiences (within and without the corporation) is imperative for success in the marketplace.

Technological Flexibility

Video is an electronic technology. It can absorb the language of older technologies. It can use all the other communications media, such as audio, slides, photographs, print, and film. But the reverse is not true.

Even film does not have this flexibility. When you want to transmit a message via film with the same immediacy as video, you have to use electronic means. Video gives you immediate recall of visual and auditory information. Video allows you to catch the drama of the moment as it happens; the advantages of speed and communications flexibility.

Accessibility

Video offers accessibility. You can transmit a video message through the use of electronic devices, such as telephone lines, satellites, and multi-point distribution systems, and have various audiences in different locations receive the message instantaneously and simultaneously. Or, take the opposite situation, where the video message is edited and canned—it is cheaper to duplicate and distribute your message on videocassette than on film. Moreover, it is easier to operate a videocassette device than a film projector.

Imagine shooting a roundtable discussion among three or four executives. The discussion can be shot live with two or three video cameras and readied for distribution almost immediately after the discussion is over.

Communications Effectiveness

Video is highly graphic and dramatic and can maintain viewer attention in a way that other media find hard to match. The medium itself is captivating, and creates audience interest, involvement, excitement and action. Today's video technology offers a wide variety of sophisticated production techniques and graphics capabilities. They allow a great deal of information to be conveyed in a short timeframe. (A Hewlett Packard study in the early 1970s—comparing sales information delivered semi-extemporaneously vs. a video presentation—found a one-hour semi-extemporaneous presentation could be condensed into a 10-minute video!) The experience of many professionals over the last two decades corroborates this finding.

Video can easily incorporate film, slides, multimedia, audio, still photography, graphic art and print elements. By so doing, a video program has greater impact than the sum of its parts. Although the initial outlay might seem larger than the up-front costs of some other media, video can ultimately be more cost-effective.

With minimal editing, one program can be adapted for several different uses—sales calls, salesforce meetings or training, point-of-purchase, trade shows, employee relations, press conferences, dealer/distributor meetings, and employee forums. It is an excellent medium for presentations because it brings life and interest to inanimate products or services.

It is flexible. If a series of videos has been produced to cover a company's product line, the entire series can be shown as one video, or individual product videos can be shown separately. By modularizing product content into various programs, future videos can be produced without disturbing the integrity of the initial program.

Video gives a company a competitive edge over companies not using video in their marketing mix. Selecting video as a communications tool indicates a commitment to progress, to technological improvements, to forward thinking.

Because the medium itself creates excitement, video is ideal for new product introductions, and equally effective for giving a facelift to older products as a company's line expands.

Video can continually update a company's salesforce, or be used for new employee orientation.

Video shortens the amount of time it would otherwise take to explain basic product features. When used as a sales tool with customers, more time can be devoted to the actual selling effort, rather than a droning, repetitious presentation of product specifications.

Video is persuasive. It can motivate more effectively than live presentations. It has authority, credibility, clout.

Working Through Change

Video presentations can also help people deal with change.

Change is inevitable. Initially, at least, most people resist change. This is particularly true when change is thrust upon us. However, people also possess intrinsic abilities to overcome their fear and resistance to change. In his book, *The Ordeal of Change,* Eric Hoffer perceptively states: "It is my impression that no one really likes the new. We are afraid of it. It is not only as Dostoyevsky put it that 'taking a new step, uttering a new word is what people fear most.' Even in slight things, the experience of the new is rarely without some stirring of foreboding."

In the corporate communications context, video can be an extremely effective tool for bridging the gap between resistance to and acceptance of change.

Let's look, for a moment, at employee communications such as orientation and training. Both of these communications events imply the employee does not yet possess a certain body of knowledge for successful on-the-job performance. Thus, the mere existence of the need for orientation and training implies change, a disruption of stable knowledge.

To take an extreme analogy, receiving new information is not unlike going to one's first day of kindergarten. You really don't know how things are going to turn out. This, in varying degrees, is unsettling. Thus, to overcome resistance to change, new information must be communicated by the best medium, and people must be motivated to accept the information.

But people are adaptive. They have the capacity to change and learn. Jerome S. Bruner in his book *Toward A Theory of Instruction* argues, "The single most characteristic thing about human beings is that they learn. Learning is so deeply ingrained in man that it is almost involuntary, and thoughtful students of human behavior have even speculated that our specialization as a species is a specialization for learning."

Bruner also points out "Almost all children possess what have come to be called 'intrinsic' motives for learning." An intrinsic motive is one that does not depend upon outside rewards. "The achievement of clarity or merely the search for it is what satisfies."

The drive to achieve competence is another intrinsic motive for learning. Robert White defines the competence motive as: ". . . directed, selective and persistent, and it continues not because it serves primary drives . . . but because it satisfies an intrinsic need to deal with the environment." Another drive that facilitates the change process is the ". . . strong human tendency to model one's self and one's aspirations upon some other person. When we feel we have succeeded in 'being like' an identification figure, we derive pleasure from the achievement, and, conversely, we suffer when we have 'let that person down.' "

Thus, while initially resistant to change, people also have the capacity to work through the pain of change because of their intrinsic characteristics of curiosity, the drive for competence, and the human tendency to imitate role models.

In order for a person, such as an employee, customer or student, to bridge the gap between resistance to and acceptance of change, two vital elements must be present: access to information and the opportunity to respond to the information.

At this point, enter video. While video is but one tool in the corporate communications media kit, it offers both cognitive and visceral communications advantages that give it an edge over other media.

The kind of information one can communicate via video offers a corporate communicator an opportunity to take advantage of people's intrinsic learning capabilities. Ronald W. Spangenberg, for instance, has shown that where the instructional task is to teach motor skills (e.g.,

operating or performing maintenance on a machine), motion is helpful in the media presentation, especially if the information is not easily conveyed verbally or the students are unfamiliar with the task. Spangenberg's work tells us a video presentation would be more desirable for teaching motor skills than a series of static slides.

One could infer from Spangenberg's work that the use of motion in teaching a motor skill via video is a logical choice. People are naturally imitative; that is, showing the action required to perform a motor skill in real time (edited, of course) via video leads the trainee to say: "What I see is what I'll do."

If you accept the concept that imitativeness through demonstration is operating during the communication of motor skills, it follows that attitude and behavior change can be similarly affected. Exposure to a role (behavior/attitude) model, according to researcher Albert Bandura, can affect behavior in several ways.

The observer (e.g., trainee, salesman, clerk) can (1) learn new behavior, (2) have already learned behavior facilitated, or (3) have already learned behavior inhibited or disinhibited. Where imitation is required video is an ideal medium for communications effectiveness.

SUMMARY

There must be a reason why television commercials are edited and distributed on video. There must be a reason why over 73% of U.S. television households have at least one VCR. There must also be some reason why, in the 1990s, thousands of U.S. business, government, nonprofit and educational organizations are using video for a variety of internal and external communications purposes (in 1973, the number was 300).

Speed, immediacy, communications flexibility, and cost-effectiveness—these are some of the major advantages video offers to help bridge the gap between employee resistance to and acceptance of change, between customer resistance and a successful sale, between public disdain and community acceptance.

New electronic technologies have created changes in the way we communicate, what we communicate, who communicates to whom and the rate at which we communicate. By the same token, video offers the

capability to help solve the problems created by change. In a very large sense, video is the communications tool needed by a society caught in the maelstrom of change. Video is both the problem and part of the solution.

We know people have the capacity to overcome their resistance to change given the opportunity to use their intrinsic abilities to learn new information.

In many instances, video is the communications bridge.

2

General Principles of Video Programming

One of the major building blocks of this book was a review of 600 articles and studies published between 1959 and 1990 on the reported use of video in the corporate context. These articles/studies yield a valuable compendium of "generic guidelines," as reported by hundreds of users, that are presented in this chapter and throughout the book.

If we eliminate duplication of guidelines among the applications, and those that are highly specific to a single application, we find the gold: *15 guidelines that generally cut across all corporate television programming applications.*

FIFTEEN RULES FOR EFFECTIVE PROGRAMS

Rule #1: Define the program's objectives. If you don't know where you're going, you won't get there.

Rule #2: Use various media for effective training. No one medium can effectively communicate everything. This is a multi-media world. You need various media to get the communications job done.

Rule #3: Let the production style grow out of the content. Let the form fit the function. The choice of production styles should be organic to the content.

Rule #4: Let the location of the shoot grow out of the content. Same as above.

Rule #5: Use professionals and non-professionals as appropriate. As with Rules #3 and #4, the choice of who appears in front of the camera should grow out of program objectives, content, and intended audience.

Rule #6: A program's length depends on what has to be said. Say what has to be said and get off the stage. Sometimes this will take one minute, sometimes one hour.

Rule #7: The production quality of the program should be a reflection of the executives appearing in it. Non-professional corporate executives deserve every break they can get. Just because they're not professionals doesn't mean they shouldn't get professional treatment.

Rule #8: Prepare talent before shooting begins. The more the talent know about what is going to happen, the better the chances for success on the set.

Rule #9: Determine your programming mix before production begins. This programming guideline is more strategic than tactical. It requires a management decision more than a creative production decision. But without it, the corporate television programmer may end up with inappropriate resources, or worse, too few resources.

Rule #10: Based upon your decision with respect to programming mix, determine what your hardware needs are. This follows from Rule #9 above.

Rule #11: Provide an adequate distribution system. So you've got great programming. If you can't get it to your intended audience, the programming will die on the vine.

Rule #12: Control the viewing environment as much as possible. This will be difficult. A corporate television programmer cannot have absolute control over when, where and how a program is shown. But the attempt must be made.

Rule #13: Measure the effectiveness of the program. So you've just produced a spectacular, highly cost-effective program. How do you know? If you don't attempt to measure effectiveness in some way (even if it means just asking the client) you'll never know if you've satisfied your client's objectives.

Rule #14: Quality is the only rule that counts. Strive for as much quality as possible, always. For survival in the 1990s there is no such thing as less quality for one program and more quality for another.

Rule #15: Promote, promote, promote. Market and publicize programming to enhance its effective use in the field.

GUIDELINES FOR SPECIFIC APPLICATIONS

Some corporate television programming application guidelines that emerged from the literature review are applicable only to specific situations. For example,

"Combine role playing with sales training tapes" and
"Use pre-recorded tapes as behavior role models"

apply primarily to role playing and sales training. Other "rules" that apply specifically to role playing are:

- Keep the size of the role play group small.
- Provide a professional role playing training staff.
- Defuse student anxiety.
- The technology should be transparent.
- Limit the length of the role playing sessions.
- For role playing, black and white may do.
- Review the trainee's progress.
- Use video to inform.

The employee news application likewise has some rules that are specific to it, such as:

- The employee news show must be viewed in the larger context of the overall employee communications.
- Producing an employee TV news show is a full-time job. Hire someone who knows what he or she is doing.
- A corporate version of Walter Cronkite does not belong on your employee TV news show.
- Keep the program to no more than 5-10 minutes in length.
- The employee news show should be the last application of video as a communications medium, not the first.
- If your company is located in a big city, employee TV news may not work.
- The cost of the employee news program should reflect its objectives.

CONCLUSION

Most of the guidelines culled from the review apply equally to all programming applications; while there are some specific guidelines that apply to specific corporate television programming applications, there are many that apply to *all* the applications.

The formula is simple: (1) define where you want to go; (2) be flexible in production choices for getting there; (3) shoot for high quality; (4) promote your program to users and audiences alike; (5) control the viewing environment wherever possible; and (6) measure the programming's effectiveness.

3

Production Principles

WHAT BUSINESS ARE WE IN?

Some say the corporate television programming business is the business of translating client communications needs into visual and aural images in a style and format appropriate for an intended audience.

Others make a distinction between broadcast and non-broadcast television. For example, in the 1970s Tom Richter, then a corporate television executive with Standard Oil of Indiana (Chicago), said, "In the broadcast industry people are concerned with production values; in the non-broadcast business we are concerned with the value of the production."

Still others conceptualize the industry as the business of communicating reality to internal and external audiences: the reality of a product (product information), the reality of personality (a management communications message), the reality of a company philosophy (a videotape about the company's attitude towards government regulation).

Whatever the point of view, it seems clear that in the 1990s the business of producing programming for corporate television networks is

closer in technology and technique to the broadcast and cable side of the television production house than was perceived in the early 1970s.

And while corporate television programming involves radically different content than broadcast television, and its style is dictated by "company" culture, the corporate television programming business is one of producing long commercials—i.e., programs that must leave the viewer sold on something: a product, a service, a personality, new information, a philosophy.

AUDIENCES: DIFFERENT STROKES FOR DIFFERENT FOLKS

Have you ever spent thousands of dollars on a management communications video only to discover the audience cared not for the fancy production techniques, but were enraptured by what the participants had to say?

Or, have you ever had the experience of spending thousands of dollars on an employee benefits video program (involving a member of management talking to an interviewer for 15 minutes) only to discover the audience cared not about "who" was doing the talking, but got really turned on to the "graphic" explanation of the new dental plan?

Corporate television producers have the responsibility of producing programs appropriate for the audience. Different audiences (and, hence, program objectives) call for different production techniques, styles and budgets. **All communications producers must analyze audiences before spending production dollars, and they must also recognize that different audiences require different approaches.**

The difference between management and employee audiences offers a case in point.

If Einstein had wished to communicate with his fellow scientists, would he have needed chroma key, quintuple exposure film animation techniques, or split screens? If corporate top management is our Einstein and the fellow scientists are middle management personnel in the field, what is the relative importance of what management has to say as opposed to the way it is said?

When the person (manager) who is saying what has to be said (to a management audience) is as important as what is being said, then the

simpler the production the better. This is not to say some music could not be used, or that opportunities for graphics should not be found, or that the participants should not rehearse the presentation, or that the program, once completed, should not have a beginning, a middle and an end.

What is important is that the "audience" for this kind of video communication has a vested interest in the information being communicated. Overdressing this kind of production will only bring a self-consciousness to the program and distract from the program's content.

However, when management wishes to communicate with *all employees,* production style, technique and budgets suggest a different approach.

In my experience most employees do not have as strong a vested interest in the company's general affairs as do higher level executives. Most employees are concerned with their immediate environment— unit, department, division. This puts employee video communications in sharp contrast with management video communications.

The rule of thumb is that the lower in the organization one goes, the more sophisticated the video production has to become. This does not mean that when management communicates with the mailroom personnel in the Basement/1evel 3, a production equalling the Super Bowl pre-game show is required. It does mean, though, that listening to the chairman of the board discuss the future of the corporation with his (or her) executive committee for half an hour will have less communications appeal to employees than a 10-minute presentation with a one-minute introduction (or conclusion) by the chairman followed (or preceded) by a nine-minute, fast-paced overview of the various components of the corporation in graphic or live action form, with background music.

Thought also needs to be given to whether the audience for a particular video communication is internal or external, management or non-management. In effect, the definition of "audience" (along with objectives) will make a considerable difference in the choice of content and production style during the scripting phase of production. (Chapters IV-XI discuss these choices in more detail).

THE SCRIPT

The conceptualization, development, drafting and honing of a script is a fundamental element in the process of producing an effective video

program. Although audiences never see the script, it is a blueprint for the construction of the program. Without this blueprint, production of an effective video program cannot (and should not) commence.

Kinds of Scripts

There are three kinds of programs from a scripting point of view: (1) pre-scripted, (2) quasi-scripted, and (3) post-scripted.

Training programs, certain kinds of employee communications programs (such as a series on a company's benefits plans), marketing and public relations programs fall into the first category. These kinds of programs are, of necessity, spelled out word-for-word before any cameras start shooting.

For example, it would be very difficult to explain the company conversion from an IBM 360 to a 370 terminal station in a tight, highly visualized 10-minute program without first detailing on paper just exactly what has to be said. In these kinds of programs the content is highly specific and detailed. Accuracy of statement is paramount. The program *must* be pre-scripted.

The second kind of program—quasi-scripted—is one usually associated with management communications programs. I have found that a semi-formal format is most successful when top corporate or divisional management is communicating to field management. What is going to be said (generally speaking), by whom and in what order, is determined before the so-called non-professional talent sits before the cameras. If there is anything pre-scripted in these programs, it is usually the opening and the close. The rest of the program is semi-extemporaneous. The "talent" rarely reads from a word-for-word script (and they shouldn't), but they should know what they are going to talk about during every minute of the program.

The post-scripted program is to be found in such applications as the employee news show, the annual stockholders' meeting or a press conference. Obviously, one cannot anticipate what everybody is going to say exactly, except perhaps the chairman's opening remarks. Thus, this kind of show is scripted "after the fact." The same is true of segments of an employee news show. A company may, for example, tape the summer intramural sports events. What happens during these events cannot be reported until after the event is over.

Script Tips

Time Is Tape

No matter what kind of program script you're dealing with, an important principle of scriptwriting is "every word must count." The test of a good script is to examine the parts. If any one part is taken from the whole and the program still stands, then that part does not contribute meaningfully to the script. It, therefore, can be edited out. That goes for unnecessary paragraphs, sentences, words, and even "uhm's."

Wherever repetition is used unnecessarily, or a half-second pregnant pause is not edited out, or someone says something that does not contribute to the forward movement of the program, this translates into wasted production and distribution dollars.

Tell a Story

A script must also have structure and direction. This means telling a story. To put it another way: "First you tell 'em what you're going to tell 'em, then you tell 'em, then you tell 'em what you've told 'em."

Another way of defining the structure and direction of the script is by stating up front what the objective of the program is. Robert Mager, speaking about training programs to the International Industrial Television Association (ITVA) several years ago, stated that the objective of the program should be the first thing the audience is told. (He also argued there should be no more than 10 seconds of music before the objective is stated.) It is useful, even in management communications programs, to state early on what the purpose of the program is.

Structure also means knowing "what" needs to be said and the logical "order" in which it should be said. This is true, I believe, for pre-scripted, quasi-scripted and post scripted programs.

An element of structure and direction is "balance" or "proportion." Too much content is as ineffective as too little. Moreover, within a program's structure, it is important to maintain proportionality among sub-subjects. For example, if there are three subjects of equal importance to be covered in a program, and subject #1 receives one minute of attention, while subjects #2 and #3 each receive four minutes of

attention, an audience could assume the former subject is of lesser relative value than the latter subjects.

Choice of language is equally important. The language chosen for a program must match the profile of the intended audience. For certain audiences, for example, the word "formidable" may be less appropriate than "vastly superior," whereas, for other audiences "chosen from various sources" may be more appropriate than "eclectic."

The toughest audience to write a script for is a very broad one. The narrower the audience, i.e., the more homogeneous the audience, the easier it is to pick appropriate language for the script.

Pacing

Another scripting element is aural and visual pacing. Imagine viewing a program in which you sense there are long pauses between statements (unintentional pauses, that is) or in which someone concludes one sentence and you "feel" that person begins the next sentence just a little sooner than he would naturally. A second can be a very long time in a corporate television program. Even 1/15th of a second can be a long time.

Visual pacing is equally as important. We have all seen programs in which a graphic or person seems to stay on the screen forever, or programs in which the visual content changed so quickly it became a blur. When used intentionally, both techniques will have their desired effect. But here we are talking about avoiding the *un*intentional use of these techniques.

I do not believe there is any hard and fast rule with respect to pacing, such as "the picture should change every 6 seconds;" I think pacing is something that has to be learned through experience. It is something that can be improved upon if the script has a sound structure and direction, is well balanced, and uses appropriate language.

Style

All the preceding elements—structure, direction, balance and proportionality, language, aural and visual pacing, making every word count—combine to give a script, and hence a finished program, style.

A program's overall style should fit the program's objective, audience and content. In an extreme example (one that actually happened), an overzealous vice president of a midwestern insurance company became involved in the production of a video training program by deciding he was going to "host" the program à la Johnny Carson. Each interview was badly handled and those interviewed were extremely embarrassed. Even though the program cost several thousand dollars to produce, it was never used. The VP didn't belong in the program in the first place, and the style of the presentation was inappropriate to the program's content.

Style also means not being self-conscious about the content or overstating the obvious. For example, when an executive starts off a program by saying, "With me here today on this video program . . ." you know the executive hasn't used video much and someone neglected to help him or her with the opening remarks. Or maybe the program script says, "As you can see, the company has a major medical plan, dental plan, and a group life insurance plan. Let's briefly discuss each one of these plans in turn." The last phrase may be overstating the obvious. The audience will instinctively know you are about to discuss each of the programs in turn.

Creativity

Creativity can sometimes get in the way. If, for example, technical accuracy is of paramount importance with regard to the script, then developing clever opening conceptual themes or dazzling graphics may indeed get in the way of the communications objective.

Adopting a straightforward, direct style may be the most "creative" style appropriate to the content. Moreover, while the content might require a straightforward approach in terms of what is said, this is not to say the script should not call for music, sound effects, or eye-catching graphics. Simplicity is usually best, although this does not mean being "simplistic."

Integration of Elements

When all the elements that go into the making of a good script— structure, direction, balance and proportionality, appropriate language, aural and visual pacing—are working in concert to create a desired communications effect, it could be said the script is approaching the

level of a work of art. After all, some of the later plays of Shakespeare were meant on one level as entertainment for the court of King James I. However, to reach the level of "artist" in the world of corporate television programming is a difficult task. And while I have seen few producer/directors achieve it, it is a goal worth reaching for.

While we are all reaching, it is worth noting that a good script—as hard as it is to create—saves time, money, and frustration later on in the production process. There can be great satisfaction after a program has been successfully viewed knowing that a good script made it happen.

GRAPHIC DESIGN

The way a program looks is as important as what is said and who is saying it. A good close working relationship with internal or external graphics design professionals or storyboardists can pay off in more communicative programs. Have the graphic designer read the script from beginning to end before sitting down to talk about graphics.

The graphics designer or storyboardist can provide that visual blueprint for a program essential for editing purposes. Very often, though, the storyboard is not the end all/be all "print" version of the finished program. It is, more often than not, a *guide* for the producer during production and post-production.

The storyboard also serves to straighten out structural and textual problems in the script, i.e., when the storyboardist visualizes the program, inherent scripting flaws often show up.

Not all programs can be storyboarded, of course, particularly those that are documentary in nature or scripted after the fact. In these instances, an offline edit serves as the video counterpart to a print storyboard.

EMOTIONAL IMPACT IN CORPORATE TELEVISION PROGRAMMING

Every time we turn on our home television set, use our home VCR, go to the movies, watch live theater, or attend a concert or sports event we have several expectations. Because we have doled out some hard-earned dollars, we expect to get our money's worth: we expect to be excited, to be moved, to become emotionally involved.

With so much entertainment available, we have become attuned to excitement during our consumption of events. We don't want to walk away from these events limp with unfulfilled expectations.

So why is it that corporate television programming does not often generate the same impact as, let's say, the movie *Die Hard,* an on-stage performance by Madonna or the mere appearance of Joe DiMaggio anywhere, at anytime?

Of course, there are some obvious differences between a management communications program featuring a company's chairman of the board and the last round in *Rocky III.* But why should the emotional impact be any different? In *Rocky III* we identify with Rocky Balboa and his quest to regain his pride, self-esteem, not to mention the heavyweight title. We respond to the cheering crowd, the well-paced film editing, the music and the situation itself: a physical fight between two muscle-clad men, each with killer instincts and highly trained skills, both vying for the same prize. And there can only be one winner.

The management communications video is likewise vested with high emotional content. This is the chairman of the board of the corporation. He is talking to me about the future of my company, perhaps the future of my job. I'd better listen to this.

But then the question is: should the marketing communications video starring the chairman of the board, with a support cast of graphics and other executives, be as interesting and exciting as the scene of Rocky Balboa beating Mr. T? Does this mean the chairman of the board's program should not have an emotional impact on us as corporate viewers? This kind of program must have an emotional impact on us in some form or fashion. If it does not, if the program does not move us in some way to think, feel and act differently than before we saw the program, then everyone has wasted their money, time and effort. Corporate videos will never compare to popular entertainment for excitement, but this does not mean these videos must be dull.

There is a mistaken belief, I feel—both on the part of executives who initiate requests for videos and the producers who create them— that these videos must be "toned down" or "not too slick" or "at least 30 minutes long" if they are going to be effective or corporately acceptable.

Production Elements for Emotional Impact

So what makes for emotional impact in a corporate video? The same kinds of elements that make any good story visually exciting and emotionally riveting.

Conflict

Let's start with the concept of conflict.

Conflict is a fundamental element in all works of art. In playwriting, it is conflict that gives a play drama. In music, conflict is the drawing power of contrapuntal music. In painting, there can be conflict and contrast between colors, shades of light and dark. Conflict is the essence of the news: conflict between ordinary citizens and government, between the cops and the syndicate, between our government and their government, between our desires for a good weekend and the forecast of bad weather, between the Mets and the Dodgers.

Without the essential element of conflict there is no drama, there is no emotional impact. The concept of conflict can be harnessed in a corporate video in various ways. When a company wants to achieve heretofore unrealized goals, there is a conflict between present market position and desired market position. Motivating a sales force or a portion of an employee population to change is a situation fraught with conflict.

If these inherent situations are dramatized in a video, people will relate to them. The conflict situation will have been used to advantage. The program will have emotional impact. Objectives and desired results just may be realized.

Unusual Situations

Unusual situations can also provide emotional impact. For example, a vice president of marketing who dresses like a member of a rock group for an annual sales meeting video is an unusual situation. It has emotional impact because it is unexpected. It rivets viewers' attention. It communicates.

Another example: hearing from customers what they really think about the product, the company, and the service provided by the

salesforce, in unrestrained terms, can have deep emotional impact, especially if top executives have never heard or seen the comments. This kind of unabashed feedback on videotape at a sales meeting can create such a high level of concentrated listening that you can hear people sweating.

Placing the chairman of the board in front of a live audience and asking for spontaneous questions is another unusual situation. While questions may or may not be totally spontaneous, the situation is. The results can be emotionally riveting.

Total or semi-spontaneous response is another way of deriving emotional impact. For example, in a management communications program, responses to questions asked by an interviewer often result in more emotionally charged, honest replies than when an executive or subject expert reads from a teleprompter. Viewers prefer honesty and personality to dryness and over-perfection, particularly when executives are involved.

High Contrast

High contrast also evokes emotional impact: sharply contrasting graphics, colors, scene cuts, unexpected wipes. Extremes of visual and aural information evoke emotional impact because they are not always expected. Video is a highly visual and aural medium. The eye, the ear and the mind are connected directly to our emotional responses.

Uncomplicated and accessible graphics can also evoke a positive emotional response. Viewers don't want to have to fight to understand what you are communicating. Bad graphics will also evoke an emotional response, of a kind that no producer or executive wants.

Music

Music also has potential for positive emotional response. The right kind of music, appropriate to the content and program objectives, can make or break a video. Too often a casual element plugged in at the last minute, music and sound effects can give a program the emotional glue that might be otherwise lacking.

One need only pay casual attention to the world around to observe that music is a central element in almost all forms of entertainment,

whether "art" or "popular culture." It pervades everything from advertising to certain forms of therapy. Music is in our homes, our cars, elevators, lobbies, airports, sports complexes, ships, boats, virtually everywhere.

Try to imagine certain "classic" films without a music score, such as *Jaws* or *Close Encounters of a Third Kind*. The latter movie *depends* on a John Williams musical motif as a central story element.

Music can provide that "tonal" underscore that moves a program along. It can add that "feeling" that is so essential to a successful program, a feeling that can add immeasurably to the success of the program's objectives.

Special Effects

Video special effects, if they are integral to and motivated by the program's content, can have an enormous influence on a video's overall emotional impact. If the video's special effects work, it is usually because there is something basic in the program's content that requires a special effect. When in doubt, though, leave them out.

EFFECTIVENESS AND COST

Emotional impact is of extreme importance if a program is to be effective. But getting this all-important emotional impact into a corporate video costs a certain amount of money. Without a proper budget, no amount of creative ingenuity and skill will get a client what they want. Let's make some comparisons.

Let's say that today a moderate-budget two-hour feature film costs, on average, $10 million. That's a per-minute cost of $83,333. A one-hour prime time television program (actual length 48 minutes) costs over $800,000—that's $16,667 a minute. Thirty-second commercials for network distribution cost on average $75,000 (on a per-minute basis that translates into $150,000). Four-minute videos distributed on MTV and other music video programs cost from $40,000 to $50,000, or over $10,000 a finished minute.

Let's say corporate television programs, on the other hand, have an average length of 15 minutes. For a broad audience program costs may

range from $20,000 to $100,000. That's a few thousand dollars a finished minute.

In effect, corporate television programming producers have no chance of producing a program that will have the same emotional impact as *Star Wars, Miami Vice* or a live performance by Prince.

Budgets for corporate television programs are paltry, relatively speaking. It is a wonder corporate producers are able to achieve what they do, and it is a testimony to the thousands of in-house and external professionals that they produce outstanding programs at all. Doing the job requires money: for good scriptwriters, art directors, video directors, production managers, on-camera and voiceover talent, music selection and mixing, camerapersons, makeup and wardrobe personnel, editing facilities, and so on.

In the corporate television programming business, as in every other, you get what you pay for. Saving 20% on a budget may get you 50% of the results you want. Producing a program with the right budget usually gets 100% better results.

The best video equipment in the world will fail in the hands of an amateur. Unfortunately there are a lot of video amateurs out there on both sides of the desk: too many clients with unprofessional attitudes and too many producers willing to let it happen for the sake of a fee. This only leads to disaster.

Everything is relative. Good video costs money. Bad video sometimes costs a lot more. With the right producer, the right concept, and the right budget, a program can be produced the first time the right way. With an unprofessional producer, with a half-baked concept and the wrong budget, everything will cost more: in re-writing, re-shooting, re-editing.

When programs are too long or too boring, audiences lose interest. They won't get the information they need to make decisions or act on. In the long run, the client is the biggest loser: all the dollars put into the video project will have gone to waste.

Emotional impact in a corporate video does not just refer to a dramatic element. A program should have emotional impact in toto.

The whole program should convey an emotion or a range of emotions that have a lasting impression on the viewer. The program should convey a message that results in a feeling, decision, or action on the part of the viewer.

The video medium is one of the most intimate that Western civilization has yet to invent. It conveys personality and emotionality at the speed of light. The television camera is a great equalizer: what counts is the person in front of the camera. And the camera does not lie. It communicates whatever is there.

Why do clients and producers do their best to make sure the medium does its worst? Why do these same individuals attempt to dilute the power of the medium, rather than harness its positive attributes? It all boils down to attitude: the television medium has its own drawing power. Even after more than a quarter of a century it still has magic. And we continue to find ways of manipulating that magic. Clients and producers can and should add to that magic by approaching the use of the medium organically; with skill, an open mind, and, above all, imagination.

Producing television programs is a group effort and provides much opportunity for collective participation. In *Rocky III* we see that while Rocky is the one who gets into the ring alone with Mr. T, he has many in his corner: his wife, his son, his trainer, his fans. Creating a corporate television program is likewise an individual and collective effort. The client is alone with his objectives. The producer is alone with the responsibility of creating an effective video.

But there are many others who participate in the process of creating the program. The scriptwriter helps conceive an approach to a program. The director helps execute the concept. The director of photography adds to the creation. The gaffer helps light the picture. The production assistants, the makeup and wardrobe people, the teleprompter operator, the technical director, the storyboardist, the set designer, the production manager, the offline editor, the online editor, the paintbox artist, the character generator editor, the actors, the voiceover talent, the music house, et al.

It is the effective management of this process that can result in a video that has high emotional impact and achieves its objectives.

HOW LONG IS A VIDEO PROGRAM?

Long is boring. Shorter is exciting.

Perhaps you've had the experience in college of asking: How long should this term paper be? In my case, I was told: As long as it takes to say what has to be said.

When it comes to corporate television programs, taking as much time as it takes to say what has to be said in one program may earn you a grade of D . . . for *d*etrimental to communications effectiveness.

A corporate television program's length will vary with the content and to a significant degree the environment in which the program is shown.

For example, an audience may not sit still for more than 15 minutes without some other kind of activity, such as a workbook, small group discussion, reading assignment, role play, or exercise. This may be because our television viewing habits are dictated by broadcast television, with the commercials. It's as if there's an internal clock operating—every so often you need a break.

Shorter programs are generally better than longer ones. But what does this mean? From one point of view it means that whatever length the producer and client consider to be the "right" length, everyone should work hard to make it shorter.

It has to do with audience and budget. Audiences want the information in as short a time period as possible. Perhaps it is because we have been conditioned to the 30-second commercial and the 120-second news story. The shorter the time it takes to tell the story, the better.

I believe it was Mark Twain who, at the end of a (relatively) long letter to a friend, closed with a P.S.: "Sorry for the long letter. Didn't have time to write a short one." Ditto for the corporate television program. Work on it.

There is also a budget ramification. More time, more money. Shorter program, lower budget. This is not always the case, but it is a good

concept to keep in mind when script length becomes a budget consideration.

Twenty minutes is a nice length. But you can't say each program should be no longer than 20 minutes. On the other hand, it can be argued that any video program longer than 20-minutes should be broken down. A potential problem is putting too much information into one tape.

Getting to know the audience is the key. Some people lose sight of the goal. Again, it depends on the content, the audience, the use of other media, the motivation of the audience, the environment the program is shown in.

And there are retention and content considerations. The client and the producer have to be aware of the content compression possibilities. I have found that eight minutes is best for certain kinds of marketing and public relations programs, for example. Two- to four-minute program lengths are "pushing it" for trade show exhibits.

It's like Churchill once said: "Put it on one page, and I'll read it." For educational programs, I recommend the information be presented in sections, if the information is too long to get into one program. In some way, the trainee should go from the tube, to a text, to a talk, and maybe back to the tube. It's disaster to put an hour lecture on tape. It'll turn people off. The information has to be broken up.

There are, of course, exceptions. If the program contains information that pertains to the audience's life style, such as benefits information, compensation, or advance selling techniques, they'll listen, regardless of the length of the program. I know of one program that ran almost an hour. It was a compilation of comments by a company's largest customers. The interviewees had been asked very direct and pertinent questions about the company's product line, perceived level of service, pricing, etc. Even the company's top sales executives had not seen the video when it was shown at the annual sales meeting. When shown at the beginning of a three-day meeting, you could hear a pin drop, the audience of 100 was so plugged in to what their customers were saying.

More often that not, however, a program should always be a fraction shorter than expected, so the audience will want more. If you have a program that contains information that is nice to know, as opposed to need to know, then the program could be over in a matter of minutes.

Although you should not be inflexible about the length of a program, the consensus seems to be a corporate television program should not run longer than 20 minutes, and preferably closer to 10 minutes.

Do not put too much information into one program. If the content looks like it will run over 20 minutes, then break it up into two or more programs.

"THE LOOK"

The requirement "not too slick" is usually uttered by producers and clients who are ashamed to admit they don't understand what producing an effective video is all about, which is another way of saying they don't like or allow other professionals to do what they know how to do. This usually results in an unexciting program.

A "toned down" program is a program that takes two to three times as long to say what has to be said because the pace is slow, or it uses too few graphics, or it has no opening or closing music because some administrator thought music in a corporate video was a waste of money. A corporate annual report may not compare with a best-selling novel, but a great deal of care and attention to detail—color, graphics, and paper texture—are employed, to create a certain emotional impact on a variety of readers.

THE DEBRIEFING: BEYOND POST-PRODUCTION

There are many reasons why something goes wrong. And despite superhuman efforts to pre-plan everything down to the smallest detail, it is still true that "If something can go wrong, it usually will."

One technique for analyzing and (therefore) avoiding past mistakes is the debriefing. While feedback questionnaires provide information on the success (or failure) of a video program, a *debriefing session* provides feedback on the process of making that program. Simply, holding a debriefing means bringing together everyone who was involved in the production and asking two basic questions: What went right? What went wrong?

The timing of a debriefing is essential to its successful application. It should take place as soon after the completion and distribution of a program as possible. If any great length of time passes, e.g., several

months, valuable insights into what went wrong with the production process may be forgotten, or incompletely and incorrectly remembered.

Who should come to the debriefing? Anyone who had something to do with the production, such as the client, scriptwriter, graphic artist, producer/director, technical director, and on-camera talent (especially non-professional), if they are still available. At a minimum, the debriefing should be attended by at least you and the client.

What are the advantages of this technique? Bringing together all those persons with a primary interest in the need for the program (the client), and those responsible for the production of the program, creates an environment in which both sides of the fence are represented. The meeting also provides a situation in which masked differences of opinion can be aired. Misconceptions can be tabled and explained. Unexplained "screw-ups" and/or difficulties in coordinating the various elements of the program can be spotlighted and analyzed. The debriefing gives all involved a sense that everyone has a stake in the production just completed (if they didn't have it during the production). If the people at the meeting are to work together on future programs, then the debriefing can facilitate closer working relationships. Last, the debriefing could also be a means of inspiring ideas for future programs.

What kind of "meeting" techniques do you use during the debriefing? The debriefing is a group discussion. And it could involve a few or as many as a dozen (or more) people. A basic technique in this situation is a variation of "brainstorming," developed by Alex Osborn of advertising agency of Batten, Barton, Durstine and Osborn (BBD&O). The uniqueness of brainstorming lies in the emphasis on quantity of contributions and in the suspension of critical judgement during the creative ideation period. By initially suspending judgement an objectivity is created in the early stages, so that later in the discussion, when a critical evaluation of the problems is discussed, it is the problems that are evaluated rather than the people.

Furthermore, while the primary objective of a "brainstorming" session is to express a quantity of creative solutions to a problem, e.g., advertising a product or presenting training information, the primary reason for having a debriefing session is to get at defining the problem (or problems) encountered during the production process, and then defining solutions to those problems.

The long-term effect of the debriefing technique is to keep clients coming back for more. The process of creating, developing and producing a video program from a client relationship point of view is just as important as the ultimate effectiveness of the program itself. A video program may do exactly what it was intended to do, but if the client feels the price of success was too high, you may have achieved a Pyrrhic victory.

The debriefing thus serves as a mechanism for fine-tuning a successful relationship among a client, you, and other production personnel, or defusing problems that could preclude the successful use of video in the future.

SUMMARY

Producing corporate television programming requires a balance between a programs's purpose, audience, and resources available to create the program. What follows are eight chapters on programming applications—from sales training to external communications. They contain "guidelines" for producing corporate television programming that are not only effective, but potentially award-winning as well.

4

Sales Training: The First Electrovisual Application

Corporate America has more than thirty years of experience with videotape as a sales training tool. Back in January 1959, Buick videotaped a roundtable discussion among some of its star salespeople; this is in fact the very first reported example of a corporate television application.

THE BENEFITS OF VIDEO FOR SALES TRAINING

A major reason for the use of the medium given by Buick's management was videotape's "flexibility." Over the three decades managers and trainers have collectively articulated six reasons why videotape works in the sales training environment:

- It is communications-effective
- It is cost-effective
- It provides training uniformity
- It has the ability to reach a nationwide audience
- It is self-instruction capable
- It provides production flexibility

By *communications effectiveness,* users mean that the video medium is the most real, the most present communications medium you can find. The closer you can get in the training situation to the real thing, the more potent your training will be.

Users have also indicated that television demonstrates rather than merely announces, that the viewer concentrates more fully on the videotape's content because he or she is on a one-to-one basis with the communicator on the screen. The communicator has at his disposal all the impact tools of television—including sight, color, credibility, intimate closeups of subject matter, animated illustrations, instant travel to distant places and important people.

Videotape technology can *reduce training costs* and time significantly. It permits the use of fewer instructors, and in addition creates savings of salaries, lodging, food, and often the expense of course materials.

For example, under an old system one company brought some 700 salesmen to the home office for up to five weeks of training. By using videotape, regional offices were equipped with videoplayers and presentations were canned. The company projected savings of about $1.5 million over ten years!

Another company observed that video would enable them to make better use of the time spent in the class by entry level account executives. It also projected a reduction in costs.

Sales training content conveyed via videotape provides a *uniformity of information and performance.* For example, in many instances sales training videos involve role modelling of an exemplary sales technique, or a salesperson demonstrating a selling sequence. The videotape medium can capture the "best" salesperson or selling sequence for demonstration to other salespeople or sales trainees. In effect, the videotape precludes different trainers from demonstrating a range of sales techniques in terms of "performance" level. This uniformity insures a higher level of training uniformity to reach training objectives.

The video medium provides *reach to a national and (in some cases) international sales training audience.* With the great accessibility of duplication facilities and use of satellites for the distribution of programming, companies can get their sales training message out to a

specific audience within days, if necessary, once program production has been completed.

Flexibility. Technology durability is also an inherent benefit of videotape in the sales training environment. Cassettes are ideally suited for the rough and tumble use characterized by use by many different individuals. Moreover, no operator is required, no darkened room. The salesperson, the training instructor—the "user"—is in complete control.

With the advent of 1/2-inch VHS players the use of sales training videotapes was no longer confined to corporate headquarters, the regional training center, or the local sales office. The salesperson or trainee can now take the sales training video home. This provides even greater scheduling flexibility.

As sales training demonstrations are produced collectively these sales role modelling videos can become a library of outstanding sales techniques and salespersons.

SENDERS AND RECEIVERS

Sales training via videotape is used by corporate staff management more than any other level in the organizational hierarchy (as opposed to top management, line division management, or employees).

And corporate America's experience with videotape as a sales training tool reflects a use of the medium for communicating information to highly selective audiences. Over half of the audiences for sales training video programming are decentralized at multi-locations, with the balance mostly centralized audiences at regional centers.

THE VIEWING ENVIRONMENT

There are two kinds of viewing environments for sales training programs: (1) special viewing rooms, and (2) routine meeting rooms (with portable viewing equipment).

At a regional center, for example, some companies show sales training presentations to all locations simultaneously on a number of television sets fed by a central videocassette playback unit.

Other companies might create learning centers: self-contained units for one person at a time, consisting of a cabinet and desk arrangement that puts everything a trainee needs at his fingertips.

In other companies, training rooms use walls as working blackboard, graphic, projection surfaces. Swivel seats permit presentations from different directions. Along with slide and film projections, video monitors are in all the spaces and an extensive off-the-shelf library of video recordings is available for scheduling by instructors.

CASE STUDIES

Referrals: John Hancock Mutual Life Insurance Company (Boston)

The John Hancock Video Network comprises 350 locations with a potential agent viewing audience of around 4,000.

"A Smarter Way" is an award-winning 20-minute sales training program that describes how insurance agents can get referrals. The out of pocket expense for this out-of-house produced program was $20,000.

According to Peter Cutler, Writer/Producer with John Hancock's Video Network: "New agents have a number of reasons for being nervous or afraid of getting referrals. They don't want to rock the boat once the sale is made and go after referrals because they feel they might lose the sale. They might appear unprofessional, embarrass themselves by desperately asking for referrals.

"We showed this feeling from the point of view of an agent being afraid through a dream, kind of nightmare sequences. We started off with a salesperson climbing up a steep rock cliff. And he just kept slipping back. This represented an agent whose career wasn't going any further. He'd reached a plateau and he just couldn't get any higher no matter what he did.

"The solution for him was to get referrals. It was an easier way to sell. He didn't have to be scrambling up this cliff. His manager was trying to talk to him about getting referrals. As the manager tried to sell him on the idea of getting referrals, the agent would have fantasies about why he didn't want to do it. He fantasized that people would laugh at him, tear up the application that they'd signed, that he would be sitting there stammering.

"Eventually the agent's manager does sell him and he gets over his fears. In the video the fears are exaggerated fears that the people are feeling, but not talking about. In the video the manager describes, step-by-step, how to get referrals and then the agent fantasizes about all the benefits of referrals.

"There are three breaks in the tape. For example, there are discussions after the beginning nightmare sequences. There is also a script that comes with the video that deals with asking for referrals, a meeting guide and audiotapes.

"Originally I kept asking the clients 'why aren't people asking for referrals?' and they kept saying 'Because they forget to.' And I thought 'That doesn't sound very realistic. It's not a very hard thing to remember.' So I knew that wasn't it.

"So I talked to some agents and wondered how I would feel in that situation, and came up with some approaches that they did respond to. Once they're not afraid to do something and they feel they can benefit from something and they can do it, they'll learn themselves. It isn't really as much the different steps that it takes to get referrals—there are probably 20 to 30 different ways to do it. It's just preparing yourself and feeling open, and feeling that you will benefit, you can do it, and there isn't a reason to be afraid of it.

"My feeling in doing these types of things is that you need to give people something new. I think entertaining is good too—although nobody knows what that really is. But if you're doing a dramatic approach, you need to do it as if you were doing a drama for film or for television. You need to have a real strong problem; you can't break character.

"And I think the audience appreciates being surprised. I think if you keep doing the same thing, they're going to get bored. I think they get bored and as long as you keep coming up with different ways of approaching it, you'll keep their attention and the audience will appreciate it and really learn something.

"We use feedback cards and people do appreciate that we go that extra distance of trying to do a first class job for them.

"I think casting is very, very important. I usually take quite a lot of time on casting. I will usually spend between 20-30 minutes in an

audition with each actor. With someone I know isn't going to work, I get rid of them. But if there is someone I am interested in, I schedule time so I can spend that much time. And I know most people don't do that here, they spend about 10-15 minutes. In a casting session you can write it and you can see how well it will work. But unless you get the right actors, it won't come across. So after the script is done you still have another 50% of the way to go.

"It's making sure the objectives are really clear, especially when you're doing something creative. You have to go back and make sure all of that is really solid. You know, when you start developing characters and start writing in terms of the character's voice and how they think and putting dramatic scenes together, you can easily go off on a tangent. You always have to come back to that objective. You also have to let yourself go because you won't be creative unless you do that. But in the back of your head the objective always has to be there. So you have to say 'Ok the next scene—what's the objective?'

"You also have to know your audience really well—usually better than your client. And one other important thing is that when you initially come into a new job in a company and you're doing video it's hard to get more really creative ideas accepted. Even in Hollywood, you run into the same thing because—it's as much a business as any corporation is. People want to see exactly what they've seen before.

"When you've got a big name in Hollywood then you can try and do something new. But you still have to fight. In a corporation when you first come in, it's the same way. Once you can get one new idea through, then they see how much better it is—that you do something that is interesting. And from that point on, they give you more and more trust as long as you don't fail. But you have to get to that point. And the only way to do that is to keep trying until someone finally says: 'Ok lets give that one a shot.' "

Fixed Income Update: Merrill Lynch

"Fixed Income Update" is a quarterly sales training series initiated by Merrill Lynch in 1985. Each program is a live satellite broadcast to 10,000 financial consultants in 470 locations. While the program is broadcast live, each program consists of "taped" segments.

According to Judy Noble, Marketing Manager for Merrill's Video Network: "I think one of the reasons it has been very successful is that

it is very consistent. Physically it has the same set. It has the same structure. And the people on the program have been consistent. It's a known entity.

"Usually the program lasts around 40 to 50 minutes. It depends on how many questions we have; we always have live Q & A at the end. This is a live satellite broadcast. Sometimes we will have certain inserts or some roll-ins. Perhaps someone we had wanted on the panel couldn't be with us that day, or perhaps there's a development and we want an additional person to say something. But the heart of it is live.

"It's often hosted by the person who is now our chief strategist—he's been promoted. He had been our Manager of Fixed Income Services. And the panel consists of the Manager of Municipal Bond Marketing; now the Chief Economist is also on the panel. We've had people in government marketing, taxable debt marketing and so forth. But it's basically those people.

"They start off with the big picture of what's going on in the economy. The host of the program talks about that. And then each person on the panel talks about their specific Fixed Income area. First, they talk about how it fits into the overall strategy. And then they talk about very specific product recommendations.

"One of the reasons I think it is effective is these people have been doing this for many years. They are very comfortable on camera. Also our company is a sales organization, people have come up from sales. So they already have presentation skills which they have now adapted to television. That's already a plus that we start with.

"Also the panel members have a high creditability rating, even within the firm. And even aside from having done the broadcast, they are well thought of and they were well known even before we started doing direct broadcast satelliting.

"Also, and I think this is real important, they admit when they have suggested things that didn't go as they had predicted.

"I think it's very important for any company to listen to feedback. It's a very important part of our programming; before and after a program we do a random sampling of the audience. We call brokers and sales managers and branch managers to get their input on how they felt the

program went; what they want to hear; what they don't want to hear; what they like; and what they don't like. And we've done that from day one.

"We started broadcast satelliting in 1984. You work according to the audience because they're right. They're the ones you're trying to reach. Sometimes you get caught up in doing television. We're doing television, but we're here to serve our firm. And that's the heart of it out there, the sales force, and that's who we have to listen to.

"There is no way for us to know how many people are watching at a time. Nor do we ask for reports. We feel that's an imposition of time and paper upon a Branch Manager. There are different ways to know if a program is successful, for example, if a product is brought up and sales increase dramatically, which has happened many times. Sales increase after a program. Or perhaps there's a lot of Q & A. People can be very quiet and that just means you've answered all the questions and you were very clear. And just doing a percentage problem of the people we call. Say we call 50 offices and you have an average of 10 each watching it, we can just take it from there.

"They rehearse an opening; a close will be on a teleprompter. They do go over what questions they are going to bring up and their bullet points. That's about all they do; it's not scripted. It's very relaxed and easy to watch.

"They also use a lot of graphics. They are selling once every three months so you have enough lead time to develop very good graphics, and they know how to use them. That's important so that it isn't just talking heads."

PROGRAM DEVELOPMENT GUIDELINES

Users have articulated eight guidelines for the use of videotape for sales training, ranked in the following order:

- Objectives/Program Styles/Techniques
- Use of Professionals/Nonprofessionals
- Use of Programs Once Distributed to the Field
- Choice Of Media
- Program Length

- Research/Script Preparation
- Field vs. Studio Production
- Combining Role Play with Pre-Recorded Sales Training Tapes

Define the program's objectives.

The first step in the development of a sales training video is to be certain the program's objectives are clear and doable. For example, the program's objectives should be stated in terms that are observable in the trainees' learning. In other words, "What will the trainee be doing after receiving the training?" or "In how much time will the learning be observable?" The learning objectives should be definable in either quantitative or qualitative terms; perhaps even both.

To develop learning objectives requires research into what is going on now, e.g., how do salespeople do certain things now, what mistakes are they making now, where are the weaknesses, where are the strengths?

Initial research should be able to define what the current situation is: what is happening now. From this history, rational and doable learning objectives can be defined. These objectives can then be translated into behavior or action that can be observed once training is completed.

Research at this phase of program development is extremely important. Research may indicate it is the sales system that needs modification, not the training system (or that more training is required). Research can also help define the demographics and psychographics of the trainees, their numbers and location. All these factors combined should help determine what medium (or media) can help achieve the learning objectives.

Learning objectives are important from another point of view. Criteria need to be developed to answer the question: did the training succeed or fail? Without answering this question, training effectiveness cannot be gauged.

Use various media for effective sales training.

Effective sales training is accomplished through a variety of media, e.g., video, slides, workbooks, role play.

The reasons for using a multi-media approach are: (1) no one medium can communicate all sales training information effectively and (2) no trainee can concentrate on one medium for great lengths of time.

Very often when a video program is shown, it is followed by an exercise in a workbook or a roundtable discussion. Naturally, these exercises and/or questions refer in some way to the information shown in the videotape.

There is also the issue of "pacing," i.e., how long can trainees look at a videotape or a print workbook or participate in a roundtable discussion before they start to lose their concentration? By changing communications media at fairly short intervals, attention span is extended and, in turn, so is learning and training effectiveness.

Examples of the multi-media approach

In one company sales training situation the trainee fills in charts, diagrams and definitions as he watches the video. When he uses the workbook he is actively involved in what's going on. The trainee must pay attention because he will have to answer questions and fill in exercises in the workbook. The last page of the workbook indicates whether or not the trainee understood the information in the video because it asks for a summary of all the information shown and all the questions answered.

In another company the trainer is part of the video. At the end of a sequence the so-called video "commentator" tells the sales trainee to turn to the workbook and refer to the material at the top of a particular page that poses a question which is character-generated on the video screen. After the question has been posed at the end of the video sequence, the trainee can shut the video off and take as much time as needed to think about the choice of conclusion (because the question and conclusions appear in the workbook). In some cases the question is supported by visual material in the workbook.

In a third example, the video's format was designed to maximize attention and retention. Trainee attention span was judged to be about ten minutes. The course material shifted from one medium to another every 10 to 15 minutes.

Let the sales training video's production style grow out of the content.

There is a host of production styles applicable to a sales training program: dramatization, vignettes, successful sales demonstrations, panel discussion, discussion groups, interviews, animation, voice-over. But which one (or combination of styles) is appropriate?

The answer lies simply in an examination of the sales training program's content, objective, and the audience to which the training information is to be communicated. Production style for its own sake usually fails. Pick a production style that best suits the content, objectives and audience.

Over the years, users have indicated that "humor" is a relevant element in sales training. Humor involves human interaction, and sales is a constant process of human interaction. Many sales situations can be difficult. Humor is one method for providing some relief to the stress of the training environment as well as in the actual selling situation itself. But a word of caution here: when using humor, do it well, or not at all. As one sage put it: death is easy, humor is difficult.

Let the location of the shoot grow out of the content.

There are those who contend all video production should be done on location. There are others who prefer to work only in a studio. There are even a few who take the position that the studio is just another location.

Those who feel the studio is just another location are missing a major point. A studio is a television production environment in which a great deal of control, i.e., technical control, can be effected. On the other hand, when on location, if something can go wrong, it most certainly will.

The issue is what is the most appropriate setting for getting on videotape what needs to be recorded for a sales training videotape. Even if reality is required, sets can always be built in a studio. On the other hand, the actual location of a sales presentation may require on-location production, not just for the feeling of reality, but for that feeling of "credibility" as well.

The choice between studio or on-location also depends on the budget. In some cases, it is cheaper to go on location, and sometimes it is cheaper to shoot in a studio.

It may also be a matter of convenience. If the sales training program involves so-called "super-salespeople" who, due to their collective schedules, can only meet in one city in a particular week, the choice of the studio may be more apt than trying to shoot everything on location. On the other hand, again depending on individual schedules, the shoot may require that a production crew go city-to-city to get the material required for the video.

Avoid pre-determined conclusions. Let the form fit the function. Let the program's content, audience and objectives tell you where and how to shoot it.

Use professionals and non-professionals as appropriate.

The question always seems to be: "Do I use professionals or do I rely on corporate executives and/or subject experts for my on-camera talent?"

The answer, again, is: it depends. If the sales training program requires an introduction by the vice president of sales and marketing, it would be quite inappropriate to hire an actor to stand in for him or her.

On the other hand, if the training program involves a successful sales demonstration, then two choices are available: use the successful sales person, or hire an actor to represent the successful sales person. The choice depends on how well the salesperson appears on camera and how well he or she handles the television production environment. Keep in mind that rehearsal and coaching can do much for a non-professional's performance.

There are some who argue it is cheaper to use in-house personnel rather than experienced television professionals. The counter to this is that, while in-house appears to be cheaper in terms of out-of-pocket, in-house personnel may also take longer, much longer than a professional to deliver their lines. Time is still money. An in-house executive may have the credibility, but a television professional can do the job more effectively and efficiently. All these factors need to be weighed.

Using professional actors and actresses means casting. The more successful corporate video directors hold casting calls. They go beyond the resume and the recommendation. They call in several actors and have them read for parts. They record the readings and make a selection on the basis of what they see on the television screen.

Another point in this regard. There are lots of actors and actresses with resumes. But only a few know how to act in a way that conveys reality, credibility, warmth, believability. Too many sales training programs fail because the acting is just not believable. If you use professionals, hire competent ones. Pay a fair price. You'll get good work and a successful program that achieves its objectives.

A sales training program's length depends on what has to be said.

Many people believe that a sales training program must be less than 20 minutes and that anything over 20 minutes belongs in another program.

The length of a program depends on what has to be said, to whom and in what context. Practice and experience indicate that 10-15 minutes is an appropriate length. Yet I have viewed sales training programs nearing one hour in length. So fascinating was the content that the time factor did not appear to be relevant.

The reverse is also true. A program should not be made longer if it will take only a few minutes to convey the necessary sales training information. Common sense should dictate. Shorter is usually better than longer.

Shorter programs can cost more than longer programs due to content compaction and production values. For example, a 30-second commercial with national distribution can cost $125,000 and up—that's $2,500/second. Every frame must count in a television commercial. The same holds true for an effective sales training program (or any nonbroadcast program, for that matter). Every frame should count. To make it count requires good production values. Production values cost bucks, even though they are put into a shorter program than originally anticipated.

Combine role playing with sales training tapes.

The use of video playback equipment alone is not as effective as use of the playback and the instant recording and playback capability of

videotape technology. The key difference is that use of the recording equipment involves role play of skills demonstrated on prerecorded sales training videotape(s). It is the combination of skill demonstration presented on videotape, coupled with the practice obtained through camera role play, that really causes behavioral change.

Role playing is a key ingredient in the sales training environment (this programming technique is given much fuller discussion in Chapter VII). The sales training environment should be designed for the achievement of training objectives. Role playing (together with pre-recorded programs) is one method for achieving these objectives.

Know the sales training environment. Insure the use of programs in the field.

Producing the program is a major step in achieving sales training objectives. But the programs must be used and used effectively. Distributing the program and getting it shown to the right audience in the right kind of environment is another major step.

It is at this juncture than many brilliantly created programs wither on the electronic vine. Even before the program is conceived and produced, it must be decided in what context the program (or programs) will be used. It must be decided where the program will fit in. Will it be videotape first, then discussion, then workbook, then quiz? Or videotape first, then role play, then discussion, then workbook, then quiz? There must be a rational integration of media before production and distribution occurs.

Another facet of this issue is knowing how many trainees will watch the program at one time. In some instances the program might be shown at a sales meeting involving 50-300 people; in other instances by only 6-12 trainees, perhaps even one. Audience size should be kept in mind when designing the sales training program and fitting it into the overall sales training environment.

Another vital aspect is having the support of management and/or training personnel in the field. Users in the field—the office manager, training supervisor, instructor, sales executive—should be committed to using the programming.

The person who must show the program must be convinced of the sales training program's value; otherwise it won't be used. An explanation of the program and its objectives, and its value to the organization *must* be conveyed to the field user or it will be used grudgingly.

This understanding can be conveyed in print material accompanying the video programming. Personal contact between producers and field personnel is also very effective. The managers who commissioned the program (apart from the program's producers) should also communicate their support and commitment for the program.

These collective activities (with the intention of generating support for the program by field users) can go a long way to insuring that the money spent on producing the program ultimately leads to effective sales activity.

5

Electronic Sales and Marketing

THE BENEFITS OF VIDEO FOR MARKETING AND SALES

One of the earliest reported uses of videotape in the corporate context was for sales promotion and marketing purposes. Since 1959 corporate managers and producers have given five reasons for the use of videotape for electronic selling, ranked in the following order:

- Communications Effective
- Technologically Effective (vs. Other Media)
- Can Reach Decentralized Audiences
- Content Can Be Controlled
- Cost-Effective

Thus, there are various ways video can help serve corporate marketers:

The quality of a video presentation is fixed and therefore consistent, rather than dependent on an individual's personality or public speaking skills.

Video is portable and easy to use. Playback equipment, VHS in particular, is available everywhere, and doesn't require the expertise of an engineer.

In many cases, video can be used as an instructional tool to educate customers about products after the sale has been made.

A well-planned and well-executed video can be useful long after the cost has been amortized, making the video potentially highly cost-effective.

Video can integrate the total marketing effort by visually highlighting various aspects of it—ads, promotions, displays. In this way, video gives additional mileage to the entire marketing and public relations program.

It is an excellent medium for demonstration purposes, either of a service or a product. In a very real way, video brings a company's product to life.

It can be used in a variety of marketing situations: dealer/distributor communications, trade shows, salesforce information, and direct marketing at point of purchase.

It can give a company a competitive edge over companies not using video in the marketing mix.

It helps re-sell existing customers. Sometimes clients need a reminder about products or services, particularly if a company has expanded its products and services. It can also keep a company's sales representatives constantly informed about a company's product lines.

It shortens the amount of time it normally takes to explain the fundamentals of the product or service. This allows more time during a sales presentation for a company representative to discuss the product or service in greater depth with a prospective customer.

It is flexible. If a series of videos has been produced to cover a company's product line, these programs can be used individually or collectively to demonstrate the line to potential customers, with or without the sales representative present.

It is a marketing and sales tool with long legs; video can be used as a "leave behind." The client contact can show the video to others in the organization, even after the initial sales presentation is completed. It makes a company's marketing effort highly portable; a company can put a lot of information on one video for demonstration purposes.

Because of the ability to create relatively inexpensive copies, the geographical reach of a company's marketing and sales effort can be easily extended.

By distributing program copies, many prospective customers can be reached simultaneously.

By modularizing product or service content into various programs, future videos can be produced and used without (in many cases) disturbing the integrity of the initial programs.

Distribution Channels

With the proliferation of videocassette players in both 3/4-inch and VHS formats in the United States and abroad, it has become easier for marketers to use video as a tool for both internal marketing communications (e.g., sales force information) and external marketing (e.g., trade shows and point-of-purchase). Marketing videos can be distributed through various channels to a variety of audiences:

At annual or periodic sales meetings. The continuing development of quality, large screen video projection systems makes presenting marketing videos to large numbers of people highly feasible.

To marketing and sales personnel at decentralized locations via internal corporate video networks. With the increasing use of teleconferencing as a marketing communications medium, canned video can be presented to marketing and sales representatives and/or potential customers at decentralized locations in real time on a global basis, if need be.

Marketing videos can be used effectively at *trade conventions.*

Increasingly, retail outlets are using videoplayers to help sell a product at *point of purchase:* marketing videos on so-called

"repeater" cassettes and videodiscs are helping to sell products direct to the consumer.

Marketing videos can help sell a distributor/dealer. Today various manufacturers are making available portable VHS players that fit into a small attache case. With this type of device, a company representative can walk into *a customer's office,* set up the VHS player in a matter of minutes, and use the power of the marketing video to help make a sale.

The International Television Association reports that 7,500 medium- to large-sized corporations are using video for a multiplicity of marketing and corporate communications purposes. Corporations have in place an internal videocassette network for the distribution of marketing and corporate communications messages. This figure probably does not include the thousands of additional organizations that do not have a decentralized video communications system, but do have videoplayers in the president's office or the main conference room.

Direct Marketing

The growth of cable television, together with the increasing percentage of television households with home VCRs raises other distribution possibilities. The experience of some of the major basic cable television networks, such as USA Network and WTBS (Turner Broadcasting) has shown that direct marketing on cable is highly effective. Although direct marketing does not constitute a large percentage of advertising on these channels, the companies that utilize this marketing method are "repeaters." This is due to high returns (i.e., sales) on the investment (use of cable for marketing) the companies have made.

By direct marketing, I am referring to the use of video to sell a product that a consumer purchases directly from the company through either an 800 number or by writing directly to the company. Direct marketing spots on cable vary in length, but many are in the 90-120 second range.

If planned for, an effective and well-planned marketing video can be adapted for use *on cable television for direct marketing.* At the very least, elements of the video can be cannibalized for the cable context.

The home VCR also presents an opportunity for direct marketing. Seven out of ten television households have a VCR. Companies are increasingly sending customers videocassettes upon request that explain and help sell the product both before and after the sale.

SENDERS AND RECEIVERS

Marketing and sales promotion programming is primarily a corporate staff communications tool, used in many cases by the marketing department or a marketing services department. Marketing and sales promotion programming is primarily directed at external publics.

PRODUCING THE MARKETING VIDEO

What makes for an effective marketing video program?

The marketing video must sell itself to a specific audience, whether the environment is a retail outlet, trade show, customer office, or sales meeting. It isn't just information that must be communicated (although information is an important part of the marketing video); the marketing video must also *convince an audience to take action* at some future point after seeing the video.

Hallmarks of a Successful Marketing Video

In this context, the elements that go into a marketing video parallel those of the television commercial. The major element is the production team brought together to produce the video. This team should include, at the very least, a qualified copywriter, art director, producer and director. Together they can create a program with the right combination of production elements.

The copywriter and the art director play key roles in the development of the script. Inherently, the marketing video should be designed to sell the product (or products) in as succinct and visual a manner as possible.

Second, the copywriter and art director must develop an immediately accessible visual and/or aural theme. This theme should pervade the entire marketing video. It should be a theme that is immediately understandable. If it takes more than a few seconds for everyone to

understand the central "idea" of the program, another theme should be found. The central idea of the program is the key to the video's success: the program's script will grow out of it; all casting, direction, music selection, voiceover and graphic treatment will be guided by it.

Third, a marketing video should be short. To some, short means ten seconds, to others ten minutes. If used in a retail outlet or at a trade show, marketing videos should run no longer than 2-3 minutes. In the sales meeting context the program could be longer. Like potential customers, salespeople want to be communicated with directly and efficiently. Long marketing videos won't be seen in their entirety. In a retail or trade show setting, a company will be fortunate if a viewer watches the entire program—the pressure is on to produce a program that communicates all pertinent and persuasive information in as short a time frame as possible.

Fourth, a marketing video should be highly graphic. Stylistically, a marketing video should be understood by a viewer watching the program at a distance, regardless of the sound track. The sound track of a marketing video will get lost in the noisy environment of a retail outlet or trade show. Therefore, the visual style of the program must be highly telegraphic. The pictures must be designed so that even if the sound were turned off (which has been known to happen), the visual elements can tell the story independently of the sound track.

Fifth, a marketing video should be informative and entertaining. Imagine yourself in New York City's Bloomingdale's. It's the Christmas season. On every floor there are thousands of shoppers. And there are thousands of items to choose from, each clamoring for attention. In one aisle is a video screen selling a scarf; the program's approach is to demonstrate the various ways the scarf can be worn. Every second of this program must not only be informative, i.e., various ways the scarf can be worn, it must simultaneously entertain the viewer. The program must capture the viewer's attention for a sufficient period of time so that after viewing the program there is an increased probability the scarf (or scarves) will be purchased. In other words, every aspect of the program's presentation should reek of "buy me! buy me!"

A marketing video should stand on its own in any context: the retail outlet, the trade show, the customer's office, or the sales meeting. Its quality should also be immediately recognizable.

In the final analysis, the true test of a marketing video's quality is the immediate reaction it provokes. Prospective buyers should feel persuaded to either seek more information about the product or feel compelled to purchase it immediately or at a future point.

Using Videos at Trade Shows

An informal survey of major exhibit houses in the United States to gauge video's status as a trade show communication medium was conducted. These companies design, construct and manage exhibit booths for Fortune 1000 corporations in a broad variety of industries, including health care, financial, telecommunications, menswear and food processing. When asked why their clients use video, many of the answers paralleled the experience of the last 30 years.

Cal Ostlund of the Long Island City, New York, firm bearing his name stated: "It gets the viewer involved in the exhibition area more." Gregory Abbate, President of ECOFA Inc., compared video to other media: "It is easier to use and more reliable than conventional methods; much easier, for example, than a multi-media projector slide show."

Hugh Wood, General Manager of Design Built Exhibits (New York City), stated the case this way: "It's one way of putting across a message in a small area. It's also a good way of demonstrating a product. Companies can show more of their product and its workings in a small space. And people who do look at it are obviously interested." In effect, video allows the corporation to tell a story in a communications-effective and cost-effective way.

Says Nick Giordano of Structural Display, Inc., "It doesn't really matter whether it's a machine show, electronics, housewares—if there's a story to be told, video is used to tell it." George Beauregard of Beauregard Corporation of Manchester, Connecticut, stated the case somewhat differently: "Clients tend to rely on the exhibit booth itself to attract people. The video is better suited for communicating information about the product."

Time efficiency is also an important aspect of marketing via video in the trade show/convention environment. According to Linda Lizardi of Universal Exhibit, South El Monte, California, "There is a need to get more messages across in a faster time frame. Video makes the exhibit

booth more competitive." She also stated, "Marketing is what trade shows are all about. And that's what video is. Video is practical and cost efficient."

The use of video at trade shows/conventions is not without its problems. Several exhibit companies point out, "You can't just send the video out." You have to send people who can supervise, install and often stand by during the show. Security can also be a problem, such as pilferage of equipment, but not so much that it is deterring clients from using video.

Interactivity

One of the major trends articulated by many of the exhibit houses was the increasing use of "interactivity" as part of the video viewing area. According to Robert Rathe of Rathe Productions, a major exhibit house in the New York metropolitan area, ". . . interactive devices such as video discs are being used more often. Several years ago, the answer would have been 'we use videocassettes a lot now.' But today video discs and computers allow lots more."

The Environment

The trade show environment presents some interesting challenges for video production. First, virtually no one coming near the booth has a high vested interest in coming into the booth (unless pre-trade show/convention marketing has been effective), and the noise level is high. This means the visual element of the video must convey a great deal of information, with the sound track serving a lesser role. The graphic elements that go into a trade show/convention video must be very well selected, while the audio track must be straightforward and uncluttered. Audio mixing subtleties in this environment will be lost.

Moreover, video is just one element in the exhibit booth. The David Gibson Company of Dallas points out that "Live demonstrations and actual products are almost always the best way for potential customers to look at something, but this is not always possible. Hence video." Robert Rathe puts video's role in exhibits this way: "We consider the trade show as an advertising medium. A trade show is a magazine, and an exhibit is an ad that goes into it. With video, trade shows are more of a selling environment now. It is an extension of advertising."

CASE STUDIES

Selling a Product: Micrascan

Micrascan I System is an instrument that's used to print semi-conductor circuits. (Originally part of the Perkin-Elmer Semiconductor Equipment Group, the division that makes this product was sold in 1991 and became the Silicon Valley Group.)

The microlithographic process prints circuits on computer chips. The technology is the latest effort by an American company to keep up with the Japanese. The machine makes wafers. The wafer is the silicon disk on which chips are exposed. Then they are cut up, pigtails are put on them, and they become part of electronic devices. In photographic terms, the wafer is the paper, the reticle is the negative. Light comes through the reticle and exposes a pattern on the wafer.

To show the Micrascan I System process of printing onto a wafer, a 5-minute, $75,000 video takes a digitized closeup of a wafer and animates it. The program describes the process and the Micrascan's accuracy. The program was originally produced for the Semicon Trade Show.

According to program producer/director Joe Fiorelli (now an independent producer in Dallas, Texas), "We couldn't take the big, humongous instrument with us, so we made the video."

The program was designed with live action (the machine operating, the wafers in closeup, the ultraviolet light exposing the wafer), computer-generated graphics, an off-camera voiceover and a scored music track.

The program was co-written by Fiorelli working with various members of the marketing and engineering departments at Perkin-Elmer.

"There are several reasons why this program works. First, you cannot take a device like the Micrascan to a trade show because it fills up a room. If you want to attract people to your better mousetrap, this is one of the better ways of doing it. You do have a captive audience, they're looking at the screen, they're seeing everything in beautiful closeup and your product comes off looking good.

"You can't get over-glitzy with your program, but it has to be splashy enough to capture your audience's attention and show off your product. The product must be the hero of the program, not the person behind the product or the people around it. It's the product itself."

Raising Money: The United Way

Marketing videos are not only used to sell a product or service, they are also used to raise funds. One example is a program produced by the United Way.

"I'll Be There," an 8 1/2-minute national fundraising program produced for the United Way in 1990, is hosted by television star Angela Lansbury (Lansbury serves on a United Way Board dealing with battered women).

According to Bruce Cooke, senior producer with United Way Productions (Alexandria, VA), "We sent out approximately 30,000 prints of the program. We're the national office of United Way and the local United Ways use it to raise money.

"We filmed the Lansbury portions of the program in the garden of her home in California. She talks about her reasons for supporting United Way and then she narrates two news documentary stories about people who have been helped by United Way. Eventually there's an appeal for people to give money or time to United Way.

"One of the stories was about a 19-year-old girl named Serese. She was an alcoholic in high school and her mother didn't realize it. Her mother was a single parent at the time. Her mother knew something was up and she tried to do something as best as she could. But one night the girl tried to kill herself . . . at the last minute she changes her mind. And she called a hotline which happened to be a United Way supported hotline. This is a great irony because the girl's mother helped start the hotline. She had been part of a community panel years earlier, obviously never thinking that she or anyone in her family would ever need it.

"Anyway, they get an ambulance there, got her to the hospital, took care of her there, then put her in a program—a United Way halfway house—where she stayed for several months, getting back on her feet, coming to terms with her alcoholism, being with people who understood what she was going through.

"It turns out today that she's graduated from college and is a television news anchor out West. She's doing well. The video gives credit to the program and the hotline that was there that night. It was a dramatic, emotional story.

"The other story is about a woman named Rosella who was an abused woman. She more or less recounts her experience. Her husband was an upstanding member of the community, and nobody believed that he could possibly beat his wife. They were well-off and her own family wouldn't give her money because, they said, 'Look you've got tons of money, what do you need.' The husband took away her credit cards, had her watched. She was living a nightmare. At one point she was fearing for her life. And she took off. She had about forty bucks in her pocket and went to the bus station and said 'How far can I go for forty bucks.' She got to a larger Eastern city. Got there, didn't know anybody, felt lost, had very little money, just ended up calling an operator and the operator referred her to a United Way women's shelter.

"She went there and immediately she has a place to stay, she gets counselling. She eventually gets into a subsidized apartment. She's now on her own. She dedicates her life to helping other battered women, so in the program she talks about the topic of abused women."

The program is combination of live interview and some re-creation. "For the Rosella story, we started out in the park and talked about what was going on, and you can see her and she's very emotional. Just seeing her was the most important thing. We have one shot of just a chair and bathroom, which sounds kind of strange. At one point the husband locked her in the bathroom and she was trapped for three days and that's when she decided she had to leave. You create the feeling. It's a real moody kind of shot with low-level light coming through the window. The next shot is the bus station; she's arriving and she's surrounded by people. Eventually she comes to this nice, warm, glowing shelter, and there are people who care about her.

"For the Serese story, we did re-creations of her mother getting a phone call at night. A shot of Serese downstairs sort of dazed, a night scene with her mother coming into the room, and then an ambulance driving up. After that point pretty much a shot of her in the halfway house. Then a shot of her as a news anchor, and ultimately ending with a nice warm picnic scene of her mother and the rest of her family."

The program was shot on 35mm film and edited on tape, but mixed back to film and tape for distribution, although virtually 80% of the distribution copies were video.

Cooke worked with freelance crews in Los Angeles and Washington, DC, to produce the program. "I took a long time to write it. I tried to build it around interviews that I had read about Lansbury. So in a sense what I wrote came very naturally out of her mouth. The beginning of the program was really based on things she had thought about and said. So it was very easy for her to talk about it. Plus we filmed it in her home, so it was a very comfortable sort of feeling.

"For the documentary stories we found moving, good stories with articulate people and then portrayed them in an understandable way. The combination of a star who was very warm that so many people like and have good feelings about, along with people that you really care about, was a really good combination."

According to Cooke, what makes these kinds of programs effective is to "concentrate on people. Rather than trying to talk about problems in wide, general terms, we just narrow down and focus on one person. When I talk about battered women, I don't talk about battered women in general, I talk about Rosella. When I talk about alcoholism, I don't talk about alcoholism in general, I talk about Serese. And that to me is the key. The emotional power in the film is based on real people. As far as the spokesperson is concerned you have to give them words to say that they really, truly believe. I try to write what they will be comfortable with, so it comes off in a very honest, straightforward way."

PROGRAM DEVELOPMENT GUIDELINES FOR MARKETING VIDEOS

Use video to inform.

The ostensible underlying reason for producing a marketing and sales promotion video program is to develop, nurture, and help close a sale. Should the program be designed as a sales tool, or an informational tool? My tendency is to say the latter. The intent of the program is to help inform the viewer of the company's particular product or service, not to make the sale. The salesperson makes the sale; the video program enhances the effort.

Do your homework before starting to shoot.

In many ways, this guideline is similar to the rules of program development for all other applications, except role playing. The rule more than suggests that the content of a program be carefully scrutinized, analyzed, sorted out, and tested before a script is created and production begins.

Various individuals should become involved. First, of course, is the client or department that wants to produce the program. Second, a producer who has the knowledge and skills to convert content and objectives into an effective program, whether using internal or external production resources, the third element in the creation of the program.

There has been some debate as to the viability of using outside vendors to create marketing and sales promotion programming. Some users argue outside vendors are necessary, particularly if there is no internal production resource. On the other hand, other users contend that because outside vendors are "outside the company," it takes too long for them to get them "up to speed." These users therefore decide to "do it themselves."

My own view is "it depends." If a company has an in-house operation with a production staff and a high level of competence, then use that internal resource. But let's take a closer look at the kind of programming being discussed. This program will be specifically designed to create and/or help make a sale. There are real dollars involved. The program is highly commercial. There is a strong gross sales and profit margin operating. The bottom line is involved. Such a program should not be created by video professionals with a training or employee communications background. At the very least, an outside scriptwriter deeply familiar with sales and marketing applications should be brought in to develop the program along with the client and in-house media personnel. Such a combination should create an effective program.

Choose a production style appropriate to the audience and environment in which the program will be shown.

Of all the applications discussed in this volume, two require a very high level of professionalism: external communications and marketing and sales promotion.

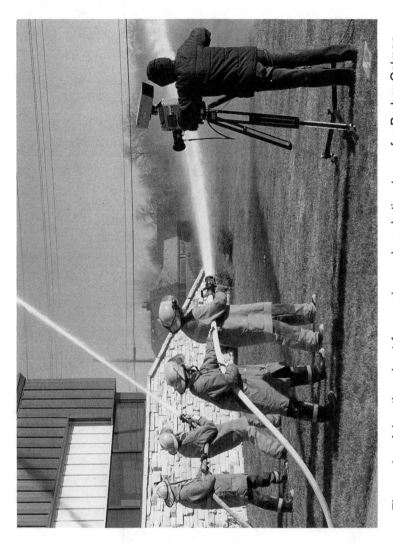

Figure 1: A location shoot for a sales and marketing tape of a Barber-Colman Governor. Photo courtesy Barber-Colman television, Barber-Colman Company.

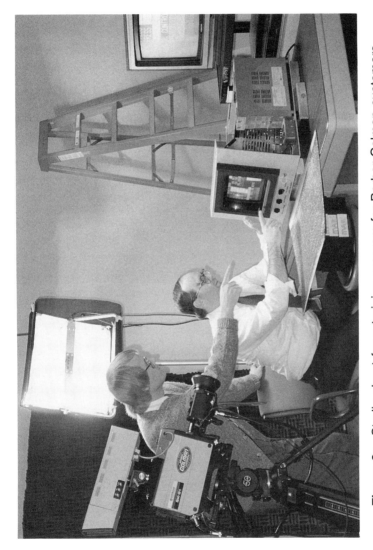

Figure 2: Studio shoot for a training program for Barber-Colman customers. Photo courtesy Barber-Colman television, Barber-Colman Company.

Why? Very simply because the audiences for this programming are external to the corporation. (This doesn't mean programming for internal audiences should not be as professional as possible; an external audience just implies a different context.) This means that, more than anywhere else, this kind of programming will be compared with commercial television and theatrical film production techniques and quality.

So, what kind of production techniques are appropriate? There are several kinds of environments in which a marketing or sales promotion program should be viewed: an office, where the audience is the customer (company president, purchasing department head, etc.); a trade show exhibit booth; or a retail outlet, where the general public views the programming. Thus, the audience for a marketing or sales promotion program could range from a few at a time to many at a time.

Knowing what kind of environment the program will be viewed in and the audience for the program should have a major impact on the style of the program. For example, if the program is designed for a small audience, fairly high-level corporate customer, the program could contain a personalized trailer by a product manager or salesperson, depending on the customer involved. The rest of the program could use a variety of production techniques, including documentary, dramatization and demonstration, depending on the content to be conveyed. Some companies have even used a "star" spokesperson in their program. This may or may not work depending on the predilections of the audience.

For a trade show, the production style may require different approaches. In this environment, the intended audience has little incentive to pay rapt attention. Therefore, the program must be sufficiently attractive to make people pay attention.

The environment for a marketing and sales promotion program could be in a retail outlet. Here the competition for attention is even greater. Customers will include people from all walks of life, all ages, and both sexes; no customers with a potential vested interest in the company's product. Here the program must be direct, to-the-point, visually attractive, informative, and short.

You may have only a few seconds, literally, to help make a sale in this kind of environment. Does this application smack of "showbiz"? You bet it does, if it's going to be effective.

The length of a program should fit the environment in which it is shown

Three viewing environments were defined above. For each a rule of thumb can be applied to the length of the program. The formula at work seems to be: the larger the potential audience at any one viewing, the shorter the program. Thus, if the program is going to be shown in an executive's office or conference room, where a meeting might take place over an hour or two, a program length of 15-20 minutes would be appropriate.

A program in a trade show environment where potential customers have at least a potential vested interest in the product or services should translate into a program of around 2-3 minutes in length.

A program shown in a retail outlet where the traffic is high and customer attention is momentary requires that the program length be no longer than one minute.

Use non-professional talent where appropriate

Customers in a retail outlet will not give two cents about the chairman of the board or chief operating officer giving a presentation on a product or service. But a chief executive customer sitting in his or her office may care very much, depending on the product or service being sold. Again, the audience and viewing environment should to a large degree determine whether or not non-professionals appear in marketing and sales promotion programming. If executive talent does appear in the program, all the rules for handling non-professionals, as defined in the sales training, general employee communications, skill training, and external communications applications, apply.

Control the viewing environment as much as possible

Whatever the viewing environment for the program, various physical aspects of showing the program should be controlled. For example, the picture quality of the program should be sharp, colors should be right, contrast levels should be appropriate. If the program is going to be shown in an environment where the traffic is high, every effort should be made to ensure that potential customers cannot adjust either the quality of the picture or the level of the audio.

Controlling the audio portion of the program presents another problem. Turn up the sound, or set up a public address system that provides adequate audio coverage for those in the immediate viewing environment but does not disturb those outside the area.

The height of the television monitor is also important. If, in a retail outlet situation, the monitor is at eye level, only those close to the monitor will see the programming. If the monitor is set higher above the heads of the traffic, then the program will not only attract attention from a distance, it will also be easily viewed by a large number of customers at one time.

Provide some training for those showing the program

If you can't be there in person, and this is often the case, make sure the person who will be using the program, whatever the context, knows how to present it.

Measure the effectiveness of the program

It is extremely important to know if the program succeeded or failed, and why. After all, these kinds of programs would not be produced were it not for the assumption the program would help create a sale.

Thus, it is imperative to define some baseline against which to measure the program's effectiveness. For example, it is important to know what the current level of sales is for a particular product or service in a given region. After a year's use you can again gauge the level of sales and see if there is a difference. Of course, one video program might not make or break the success of a sales campaign; but it could.

Salespersons can provide additional feedback. Since they are on the firing line, they have a direct "feel" for the contribution of sales tools to their success.

Another method of gauging effectiveness (presuming there has been an analysis of the past and current level of sales by country, region, state, locality, product, retail outlet, etc.) is to provide customers with feedback cards that ask about the effectiveness of the presentation. You'll soon find out what kind of contribution the program made.

While the major way of gauging feedback is increased sales, you need to determine if the program helped contribute to the increased sales and not some other factor. Consider using an outside professional to help design the feedback mechanism. A good book on the subject is *Is it Worth It? Evaluating Video Programs* by Laurel Sneed (Knowledge Industry Publications, Inc., 1991).

6

Skills Training: The Ubiquitous Instructor

The use of videotape for skills training has been ranked in the "top three" on the list of corporate television programming applications ever since its use was first reported in 1960.

For example, 1974, 1977 and 1988 industry studies ranked skills training as third highest; a 1979 Knowledge Industry Publications study and the 1981 and 1985 studies by the International Television Association (ITVA) ranked this application at the top of the list.

Other kinds of "skills training"—job training, supervisory training, management development and proficiency upgrading—also receive high rankings from all the studies. "Specific Job Training," for example, is ranked second highest and top of the list in the early 1970 studies. The 1981 ITVA study ranks the application as second highest.

SENDERS AND RECEIVERS

Videotape for skills training is primarily a corporate staff management and line division management tool. Audiences for the medium in

this application are specific: e.g., select employees company-wide. A skills training environment implies certain individuals or groups of individuals needing specific skills.

This is evident from the location of audiences for skills training programs. Over the years, sixty percent of the audiences for skills training programs have been decentralized at multi-locations. Thirty percent are centralized at corporate headquarters. Only 6.7% are decentralized at corporate headquarters, and 3.3% are centralized at regional centers.

THE VIEWING ENVIRONMENT

Over the years, users have indicated a variety of physical viewing environments: special viewing rooms; routine meeting rooms with portable viewing equipment; with portable viewing equipment (outside meeting rooms); and in employee's homes.

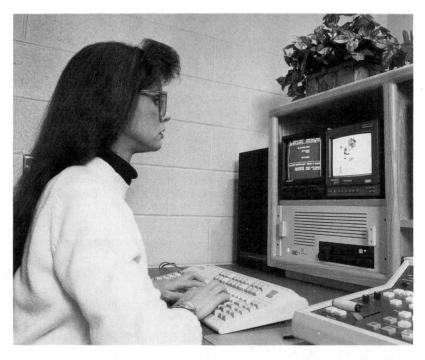

Figure 3: Using the Dubner 20K Computer Video Graphics. Photo courtesy of the Tulsa Vo-Tech School Department of Curriculum/Media.

Usually, monitors are set up right in the training room, along with other training media such as an overhead or slide projector. In other instances, training areas are equipped with earphones so that the noise from the videotape will not bother other employees still at work.

Training videotapes have been shown around the clock in a department's maintenance area. In one company monitors, mounted on brackets in 19 buildings, were situated to allow quick communication with all manufacturing personnel. With the addition of several monitors in a company auditorium and cafeterias, as many as 18,000 employees were able to view special training presentations in a single three-shift day.

Another company's training department used a 60-foot trailer in the plant as a classroom for various training programs. Other companies boast training complexes, with classrooms, conference rooms, cafeteria and dorms.

Companies have shown great flexibility in showing videotaped skills training presentations to employees. For example, in one company the tapes were duplicated and used in the plants in small group sessions of 15 to 20 employees and one moderator. For some training programs, the playback equipment was taken out on the plant floor. Tapes were then sent out on the videocassette network, providing workers with individual guidance right at the plant level. Supervisors were encouraged to take a player and monitor and do the training on a one-to-one basis. After viewing the tape and using the associated print materials, the mechanic trainee was expected to practice what he learned.

THE BENEFITS OF VIDEO FOR SKILLS TRAINING

Since 1960 managers, trainers and producers have expressed nine benefits of the use of videotape for skills training purposes, ranked in the following order:

- Communications effective
- Efficient and flexible to use
- Can manipulate real-time/real life while maintaining realism
- Cost-effective
- More effective than print and other media
- Reaches decentralized audiences
- Extends the subject expert

- Uniformity of instruction
- Fast turnaround from production to distribution

Communications Effective

By communications effective, users mean that using videotape for skill training gets the message across, communicates content effectively, and helps get skills training results.

Efficiency and Flexibility

Users appreciate videotape's efficiency and flexibility, especially since the commercial introduction of the helical-scan U-matic format in 1971.

Manipulating Time; Maintaining Realism

Videotape has several positive characteristics in common with film. For example, when users comment that videotape can manipulate real-time/real-life while maintaining realism they are referring to film's capabilities as well. Film and videotape have the ability to shift time and space. Both media have the ability to compress events in terms of time. They can shift the order of events. They can shift place. One moment you're in the chairman's office, the next in the shop foreman's car.

Both videotape and film can duplicate realism as well as record it. One key difference between film and videotape in this regard, however, is that videotape looks more like events are happening "now," whereas film has an aesthetic quality of happening in some other place at another time. High-definition television (HDTV), which looks like a blend of videotape and film, presents a different feeling altogether. HDTV is probably the next step between videotape and three-dimensional projections.

Cost-Effectiveness

Videotape's cost-effectiveness as a skills training medium is obvious. Videotape stock is far less expensive than film. Because it is instant record-and-playback capable, shooting and editing is faster. Duplication is a lot less expensive. On the basis of the out-of-pocket costs of videotape alone, videotape presents numerous cost-effectiveness advantages.

According to Hope Reports (Rochester, New York), a leading source of data on media, companies spent about the same on film production—about $500 million—in 1985 as they did in 1975. For the same period, corporate spending on videotape production increased manifold, as follows:

Corporate Video Production
1975 $220 million
1985 $1.6 billion

(In 1975 corporations spent $644 million on slide production, and in 1985 spent $5.3 billion, a significantly greater sum than corporate videotape production.)

Video vs Print

Users have also indicated that videotape is more effective than print and other media in skills training, because videotape can present certain kinds of information more effectively.

For example, it has been shown that motion is helpful when the instructional task is to teach motor skills (e.g., as in operating or performing maintenance on a machine), especially if the information is not easily conveyed verbally or if the trainees are unfamiliar with the task. This suggests that a videotape presentation would be more desirable for training purposes than a series of slides or a print workbook.

The use of motion (video) to teach a motor skill is the most logical choice because people are naturally imitative. This imitative process operates from birth. Studies have shown that babies imitate adult rhythms of speech through physical expression—movements of hands, arms, feet and head. This rhythmic, physical dance is clearly evidence in adults: the pointing of a finger at the end of a sentence, the shift in body during conversational transitions, the leaning forward for emphasis at the beginning of an important statement.

If one accepts the concept that imitativeness through demonstration is operating during the communications of motor skills, it follows that attitude/behavior change in a trainee can similarly be effected. Exposure to a role model, as in a supervisory training program, for example, can affect post-training behavior in several ways. The observer (trainee,

salesperson, clerk) can (1) learn new behavior, (2) have already learned behavior facilitated, or (3) have already learned behavior inhibited or disinhibited.

Thus, when imitation is required—learning a motor skill, learning an attitude via real life demonstration or role models—videotape is an ideal medium for communications effectiveness.

Decentralized Audiences

Videotape also has the capability of reaching decentralized audiences. With the advent of the helical-scan U-matic format in the early 1970s and subsequently the VHS format in the mid-1970s, it became very inexpensive and efficient to use videotape as a means of reaching corporate-wide audiences.

Use of Subject Experts

Given this kind of distribution capability, videotape also has the advantage of extending subject experts. A major problem in corporate training is getting pertinent information to everyone who has a need to know. Experts in a particular subject have a level of expertise that is not common in the organization. What they have to say is significant.

Unfortunately, too many subject experts are terrible communicators. And, even those who are adequate communicators cannot be in all places to communicate their expertise on a timely basis.

Enter videotape. In some cases, a subject expert's presentation will be merely recorded, duplicated and distributed to all trainees throughout the corporation. More often a subject expert's videotaped presentation will form the basis for a highly scripted, visualized and well paced videotape that is properly shot, edited and then distributed.

Uniformity of Information

An ancillary benefit to this approach is that training information becomes more uniform. You do not need to depend completely on trainers with a range of competency to present more or less the same training content. While the videotape presentation cannot be the ultimate equalizer, it can help reduce some of the training quality inequalities that are bound to occur.

Fast Turnaround

Film has had extensive use in corporate training but it presents many limitations. There is no instant playback; you cannot see what you have just shot to make sure you "have it in the can." You cannot go from production footage to an editing mode overnight; film first has to be developed through a chemical process. You cannot create visual and special effects on film with great ease and cost efficiency. Even creating program titles is difficult with film (and relatively expensive). And even after you create the visual effect, you don't get to see what you've done until after the film has been processed. With film you work with an editor who puts the program together in a manual/mechanical process. If you want dissolves between scenes you don't get to see how well they work (or don't work) until after negative matching. A film can take several weeks to produce from production to release prints. A videotape, on the other hand, can be shot, edited, duplicated and distributed in 24 hours, if need be.

CASE STUDIES

The case studies in this section are included because the ITVA gave them top honors in the training program category.

Braces: Case Western Reserve University

A French practicing orthodontist came to Case Western University Dental School to get her Ph.D in children's orthodontics. Her thesis was on motivating teenagers to cooperate with their orthodontist.

According to Gay Anderson, Producer/Director at Case Western University, "Orthodontists are interested in motivating kids because they want the kids to get their braces off as soon as possible (so they can get more patients in a shorter amount of time), and if the kids have their braces on too long they end up with problems with their teeth when they remove the braces.

"The orthodontist wanted to get a video produced that she could show to teenagers and use along with a workbook that she was writing as part of her thesis. The workbook was on how to get teenagers to cooperate and how an adult can communicate with them.

"She had written a script and wanted to use real kids and have them act out parts. The script was awkward because she doesn't speak English

very well, so some of it didn't translate into American language very well.

"The first thing I did was look at other films that had been produced for the same purpose. They all tended to be from the point of view of an adult explaining to a child what to do or what not to do and how your braces work.

"Then I saw one film where they used the concept of using kids, but it was so hokey—they tried to do it in rap. It was something you'd laugh at more than listen to."

The audience for the 11-minute award-winning videotape Anderson ultimately produced were 11-17 year-olds who are either going to get braces or who wear braces.

"The audience for this kind of program is tough because it's not like an adult who's fairly motivated to come in and finish his dental care. Teenagers sometimes don't see that their behavior affects whether or not they get the braces off or how long it takes to get the braces off. So I came up with the idea of doing it in a way that I thought wouldn't alienate kids and would make them listen to the message. The idea I came up with was to use kids talking to other kids. Half of the kids already wear braces and have experience that they can give to the other kids who don't have braces yet but have to get them.

"The premise of the program is that they are making a home video about braces. To establish that the opening scene is some kids looking into the camera and talking about focusing it, white balancing, they have a little slate. Then we zoom in on the first character who tells us, 'This is an educational video about braces. We're going to tell you how to take care of your braces.'

"The rest of the video is supposed to appear as though the kids have actually shot it—the kids talk to the camera and talk to each other on camera throughout the program. There's lots of graphics and music segments.

"When I think about why this program was successful the first thing that comes to my mind is that I had the time to research what this woman had found out in her research. When I first approached it I remembered that I had braces on when I was a kid so what would I respond to?

"Also, when someone is invading a personal space like your mouth, especially when you're a teenager, that's about as close to someone as you can get. And when you feel awkward and ugly—you're 14 years old, you've got crooked teeth and some adult is sticking his hands in your mouth—it's like an invasion, it's pretty intimate.

"Reading things like that, learning what she found out about teenagers, was really important.

"Also, I knew that I wanted to use humor. This is not an earth-shattering topic. To a 14-year-old who has braces it might be, but I think they would appreciate your approaching it with humor. I think it's the humor that makes it work."

There were about 10 teenagers in the program. Anderson had held auditions but found that all the "professional" kids who had extensive print but little acting experience were either too stiff, too precocious or too expensive ($500 a day). The entire budget for the program was $10,000.

So she cast kids who were patients at the university's dental clinic. "I treated the kids like adults and let them give me input and made them feel like they were friends. They were treated with respect. Here's a job you're being paid for. I need you to approach it in a responsible way."

Six kids who had the main parts were paid $100 for two days of work and the other kids who had non-speaking parts were paid $30. The whole program was shot in her house.

According to Anderson: "You have to realize that video probably isn't going to teach somebody a skill. If you want to teach somebody how to ride a horse, if you showed me hours of video on exactly where to put my foot in the stirrup and how to swing my leg over the horse and how to tell the horse to move and then you put me in the field and gave me a horse, I would have a little bit more knowledge than someone who hadn't watched the video, but I probably wouldn't be able to do it very well anyway without a human being there, giving me feedback and telling me what to do and what not to do.

"You have to realize video's limitations and never promise anybody something that it can't do—which is replace the human being. But it can get a person's imagination going.

"To get someone to learn something, first they have to want to. I can't show someone a video about a skill if they don't want to learn the skill. I think the video can function better to inspire somebody or get their imagination going.

"So, first it's important to show someone why it's important to learn something. First convince the viewer it's worth their while to watch and then show them the information."

Making a Difference: New York Department of Social Services

"The purpose of 'Making a Difference' basically was to help train homecare workers who have to work with people who have AIDS," says Sharon Wolin, the program's producer. The program was distributed to thousands of homecare workers throughout New York State.

"It needed to break down some myths and show just how to deal with people with AIDS. At the same time we also needed to try to make them empathetic towards people with AIDS, because a lot of people who are in home care really can refuse to work with an AIDS patient.

"The home care workers needed to understand what is it like to take care of AIDS patients. It is not a step-by-step training program—first you do this and then you do that. It was a training program that meant to change mind sets as well as make the audience aware of what is involved in taking care of AIDS patients: what you have to do physically; the types of foods they can and cannot eat; when you have to wear gloves and when not; and taking care of babies with AIDS.

"It also covered the emotional aspect of having to deal with an AIDS patient. You're not just dealing with a person who is sick, you're dealing with a person who is dying. There are a lot of emotional traumas that go on with that as well as having to deal with the family, friends and loved ones."

The $45,000 program runs a little under a half hour. Wolin pointed out that the program was not a stand-alone piece. "They had a printed brochure that went with it. It was also going to be shown in classroom and other training situations, so that the piece could be discussed. There was normally a social worker or home care worker available who could fill in the gaps and answer questions.

"This program turned out to be a fully scripted drama. The program starts at the end of a class where home care workers are being taught and the teacher remarks, 'Tomorrow we're going to start talking about working with people with AIDS.' Someone comes up to the teacher after class and says: 'Look, I'm having problems with this. I've got kids, I've got a home life, I'm afraid to work with someone with AIDS.' The teacher says, 'Well, your fears are certainly not unique, a lot of people feel that. Why don't we look at a case study and get a better understanding.' And she starts talking about a case study. At this point we transition to seeing that person with their home care worker.

"The next day the home care worker is late meeting her friend for lunch. Her girlfriend says 'Why?' She explains, 'I was having a little trouble dealing with the fact that we're going to be working with people with AIDS. Her girlfriend says, 'Yes, I went through that recently,' and starts telling her about another case study. This time with a single mother who has AIDS and whose child has been born with AIDS.

"We come out of that scenario and we are in the classroom the following day. The teacher says, 'We're going to start talking about people with AIDS. I've got a case study.' And she turns on the TV set and we transition into a third case study. That last case study is about a man who is dying of AIDS and is living with his sister.

"We had ten main actors and about 20 extras. I think one of the things a lot of competitions look for is 'How creatively can you meet your objective, and still get your point across. How good are the production values?' I think the program met its objectives because by the end of the program you really found out something about people with AIDS. Also, the actors were very good. You learned more than just about the disease, you learned about the victims as people.

"I think the most important thing is to really understand who your audience is; where they are coming from and what prejudices they have. You can be very intelligent, but if your audience is at a tenth grade level, then you have to consider 'How am I going to get my message across to these people?' That's number one.

"Number two, it is important to think creatively. Anyone can do a training film where you have narration and you tell people 'You start with A and you end with B.' And you have full narration and you have

video cover. But that's very boring. I think almost any topic can be approached in creative ways, and I think the more creatively you approach it, the more your audience is going to sit and watch it. And third, I think you have to follow through on good production values."

PROGRAM DEVELOPMENT GUIDELINES

Managers and producers have expressed various guidelines regarding the use of videotape for skills training, including a concern with production styles, content styles, use of the program in the field, program development and the trainer's role.

Clearly, production style and content style are the most prominent principles of concern to users. Content style here refers to the kind and structure of the information to be presented in the program. Production style refers to the style in which the material is to be presented from a television point of view.

Accordingly, the following programming development guidelines apply. The reader will readily note that several of the guidelines just as easily apply to all of the other programming applications discussed in this book, for example: defining objectives, defining success and failure yardsticks, defining the audience's profile, determining the environment in which the audience will receive the video programming.

And while there is some redundancy among the various programming applications guidelines, the above aspects seem more pertinent to skills training than to some of the other applications. This may be because skills training has been for more than 30 years the major use of videotape in the corporate context. It is this programming category that has received significant emphasis.

Define objectives

If you don't know where you're going, you won't get there. Clear definitions of program purpose, audience and audience environment are prerequisite for all applications, but especially so for skill training.

Clearly, the skills training programming application demands that clear training objectives be articulated before any videotape production begins. It has also been suggested that these objectives be given to

trainees at the beginning of the training program to insure effective results.

While this guideline applies to all the programming applications discussed in this book, there are important differences between defining objectives for "training" and "marketing" programs, on the one hand, and "employee communications" and "external communications" programs, on the other.

The former category allows for the definition of results (as against objectives) that are highly measurable. For example, if the objective is to have someone learn how to do something mechanical or increase sales by 15%, these objectives are observable and, therefore, measurable.

On the other hand, measuring results for the latter category of programming applications is much more difficult. For example, how do you measure increases in employee morale (other than in a longitudinal employee survey) or increases in public awareness of a company's perspective on certain political issues?

In the first instance, you are measuring something that can be *quantified*. In the latter instance you are attempting to measure something on a *qualitative* scale. And while there are a variety of measures for the quantitative and the qualitative, the former is much easier. Which brings us to the next guideline.

Define how you will measure results against skill training objectives

Whatever the underlying objectives, the program must create change that can eventually be measured.

When trainees have to learn how to do something with their hands, for example, trainers and management will be able to tell within a relatively short period of time whether these manual skills have been mastered. To measure the results of the training videos is relatively simple. The trainees have either learned the skills or they have not in the period of time they were supposed to learn them.

If management has defined the objectives of the training programs and some measure of success (or failure) has also been articulated, then results should be forthcoming in some form.

The first step is to assess the current situation. Assume, for example, that a training program is expected to increase production in a manufacturing plant by 15%. The company must first determine employee productivity for a particular job function as of today. Without this knowledge, no post-testing will have any validity. Once this information base has been established, it can be determined later whether or not the training program succeeded.

There are at least three kinds of changes than can and should be measured: (1) change in quantity; (2) change in quality, and (3) change in attitude.

A change in quantity is simply a measure of numbers in a given period of time. For example, analysis may show that X number of employees currently produce 20 widgets an hour. After dissemination of the video training program, evaluation may show that productivity is now 30 widgets an hour—productivity has been increased by 50 percent.

A change of quality refers to the degree of change in performance parameters. For example, if the yardstick for measuring results was plus or minus five percent of the given performance parameters, then management will know that the skills training program has failed when post-testing reflects performance parameters in excess of plus or minus five percent.

When evaluating a change in attitude, management can ask several questions designed to evoke a range of answers. For example, management could ask: Now that you have viewed this skills training program how do you feel about your role as a new supervisor? The same as before, less receptive to your new responsibilities, or more receptive?

A change in attitude may not be evident immediately; the audience may need time to digest the new information. It may be days, weeks, or perhaps even months before a change in attitude is measurable with any degree of significance.

In a sense, though, any video program (skills training or otherwise) must have a degree of attitude change and/or motivation built into it. In some instances, of course, the audience may be self-motivated; they may have a vested interest in the content and understand from the outset that certain benefits will accrue to them from learning and understanding the information in the training program.

Just what will motivate employees to accept new information or get an audience to ask "What's in it for me?" can be determined by an analysis of the audience before the program is produced.

Define the audience's profile

Any marketing executive worthy of the position understands the critical importance of "knowing the market"—it is an essential part of a successful marketing strategy.

It would seem preposterous for a company to produce a skills training program without knowing some basic facts about the audience that is intended for the training program. At the very least, skills training programmers should have a basic demographic and psychographic knowledge of the audience: sex, age, staff level, familiarity with technical terms and predisposition to the subject matter. An audience's predisposition to content can destroy a skill training program that might otherwise prove effective.

Sometimes top management has a filtered, subjective perception of personnel in various parts of the organization. Questioning a segment of the prospective audience can avoid the trap of communicating skills training information in a manner inappropriate for the audience's needs. Almost any audience will block out the intended message if they perceive that the programmers are not really directing the message to them.

If I feel that the person who is attempting to communicate with me is not speaking to me in a way that I can relate to, or is not giving me information that I find relevant to my needs, the chances are high that the skills training program will not be effective. Audiences know instinctively if the program producers took some care with the video. It is only considerate to ask a portion of the audience what it really wants and needs to know and how it wants to be communicated with.

One result of this approach is that the audience will in no small measure tell the programmers how the skills training program should be prepared. The process should result in a more effective program and the chances of realizing defined objectives will be enhanced.

Last, it's a lot cheaper and safer to put aside pat assumptions about an audience's predispositions and ask questions at the beginning of the

process than to have to answer embarrassing questions at the end, when money has been spent and the skills training program has failed to achieve objectives.

Define your audience's location

The location of the audience for the skills training program must be considered. Getting the program seen in the right kind of training environment makes it effective (or not).

Certain questions should be asked, including:

1. Will the audience congregate in a central location or will several locations receive the program?

2. Are there individuals available at the location(s) to present the program?

3. Must the program be available to anyone at anytime?

4. Will small or large groups need to view the program?

5. What is the program's shelf life?

6. Is the audience in the United States or at some international location, or both?

Further, the most articulate, graphically pleasing, well-written skills training program will not work if the environment in which it is to be used is noisy, dirty, distracting, or cannot accommodate the size of the intended audience. Many a program has bitten the dust because the air conditioning in the training room was too loud. And if the audience must be cramped into a small space and the view of the television monitor is blocked in some way, the program's success will surely be threatened.

Did the skills training program succeed or fail?

This question must be asked at the end of the skills training process—otherwise a great deal of work will have gone for naught.

The whole premise for using videotape in a skills training or other environment is to achieve some kind of result. There are basically two

results managers and video programmers can hope to achieve: (1) to make knowledge more productive, and (2) to create understanding.

Making knowledge more productive is the underlying assumption of videotape's power: to train, to educate, to help sell. Creating understanding is another major aspect of videotape's magic: it helps convey concepts, processes, personality. Videotape is both a "gestalt" and a "sequential medium." On the one hand, videotape has the capacity to present "total pictures." On the other hand, videotape can also present information in a sequential, logical manner, and do it in a consistent way every time.

With this kind of communications power available, corporate network programmers should make a habit of testing the results of their endeavors: did the program work or didn't it? Did the students get the information they needed or not? Did skill levels increase as a result of viewing and working with the video or not?

It is results that count, not Hemingway-like prose, eye-grabbing graphics or intoxicating music. When an audience returns a verdict of "We got it and it works" this is when the corporate network programmer can truly be proud.

7

Role Playing: The Electrovisual Mirror

Feedback is critical in the training situation: Did I get the information right? Am I performing the skill correctly? Am I getting the right results? It is particularly important in sales, management communications and media relations training. And in each of these environments, videotape can serve as an instant, no-fooling around, tells-you-the-truth, electrovisual mirror.

Role playing can be defined as a training environment in which two or more trainees are placed in a simulated situation in which each plays a pre-defined role. An example can be drawn from insurance sales training. The physical environment is a couple's home. One trainee might play the role of the husband; another, the role of the salesperson. Videotape's role in this context is to record the interaction among the players and provide an instant mirror of the trainees' performance following the role play.

SENDERS AND RECEIVERS

The earliest reported use of videotape for role playing occurred in 1964, some eight years after the introduction of commercially viable

videotape and magnetic recording technology. The only industry study to specifically mention "role playing" as a separate and distinct application is a 1969 study published by the American Management Association (AMA).

Perhaps the reason lies in timing. The AMA study was published before the commercial availability of the 3/4-inch videocassette in the United States in 1971. Perhaps the ability of the 3/4-inch videocassette (and subsequently the 1/2-inch Beta and VHS formats) to create and distribute programs makes this characteristic more dominant than the instant playback feature that is essential to role playing.

Videotape has been used for role playing by staff management more than by top or line management. It is extremely popular for sales training, and is also being used for management/employee communications and media relations.

There has been a tendency to centralize the role playing equipment, regardless of the videotape technology available. Only in one case, mentioned in a July 1977 article, does the availability of highly portable equipment seem to provide a "decentralized" example. In this case, the role playing equipment and program was brought to the participants.

In all other instances, trainees gather in central locations to receive training that consists of role playing activities. The majority of audiences are centralized at corporate headquarters or regional centers.

THE ROLE-PLAYING ENVIRONMENT

The environment for role playing can range from a simple table and two chairs to elaborate settings. It is apparent from users' descriptions that through 1972 most role playing situations consisted of a classroom setting: students observed the role playing situation, and the camera and recorder were in the room. Since then, the role playing environment has become far more elaborate and varied. In some instances, the trainer runs the VCR and the camera; in others, a technician is brought in to handle the technical side of the role-playing session, as described below:

- The environment is capable of simultaneous recording of various role playing situations.
- Videotaping equipment is hidden from view of the role playing participants.

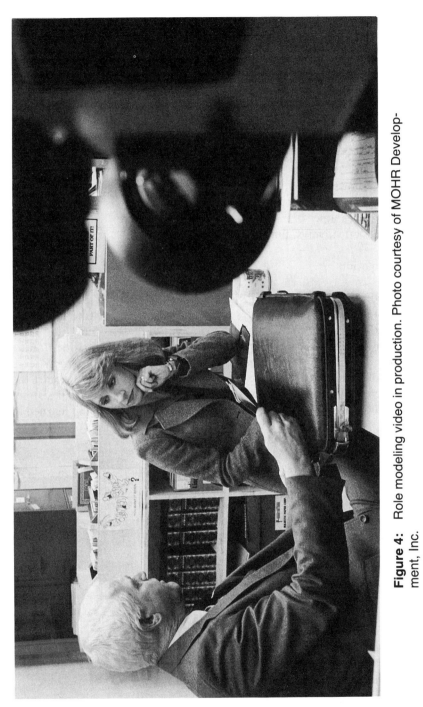

Figure 4: Role modeling video in production. Photo courtesy of MOHR Development, Inc.

• The environment is specially prepared, with a formal setting for role playing and formal areas for reviewing the role play tapes.
• The role play environment depicts with greater reality the actual "communications" environment such as a supermarket or office.

THE BENEFITS OF VIDEO FOR ROLE PLAYING

Managers, producers and trainers have given four reasons for the use of videotape for role playing:

• Allows trainee participation
• Simulates reality
• Saves time
• Is effective vs. film

Participation

When users indicate that videotape "allows trainee participation" they are alluding to videotape's ability to bring a trainee into a learning situation on a visceral as well as cognitive level. It is one thing for a trainer to "lecture" to a group of sales trainees; it is quite another for the trainee to be involved in the learning process with videotape. When a trainee is videotaped in a role-playing situation, the trainee becomes the "content" of the training environment. While there is a certain amount of "product information" to be learned, what is really being learned in a role playing training environment is "inter-personal" or "people" skills, dealing with emotional content and change.

Videotape also allows trainee participation on the playback side of the process. People watching people is one of the conceptual pillars of "Candid Camera." So, too, with videotape and role playing, except there's a twist. In the corporate role playing context people watch themselves. And while it is engaging and compelling, it can sometimes be painful.

Simulates Reality

Trainees can simulate a sales context, for example, and play parts in order to feel their way through the situation. The training is achieved through feeling (1) the informational content and (2) the emotional context. The combination of trainee participation and simulation of reality gives videotape its cost effectiveness and efficiency, i.e., "it saves time."

Valuable for Rehearsing

One of the major tenets in media relations is to come before the press with your content agenda *pre-planned*. Regardless of the questions asked, the executive answers with a pre-planned rather than off-the-cuff text. The former is more directed; the latter potentially a public relations disaster.

A sales situation further illustrates the point. If you have rehearsed your sales pitch, dealt with objections in advance, and pre-planned a smorgasbord of closings, the chances of getting the sale are much better than if the salesperson has not practiced.

Similarly with management/employee communications. In the last few years, as a direct result of mergers and acquisitions, foreign competition, the globalization of many industries and markets, and new technologies, American corporations have gone through significant organizational changes, not the least of which is the flattening of the organizational chart. As a result many managers have had to learn how to deal with the fallout: people losing jobs; people changing jobs and careers; people learning new skills—in other words, people having to deal with change. With videotaped role playing training, people can "practice" dealing with employees before having to deal with "the real thing."

Instant Feedback

Last, videotape has a major advantage with respect to the role playing/training environment: its instant playback capability. Film cannot be played back instantly, nor can slides or photographs. Videotape's "magic" in the role playing environment is its ability to be rewound and played back instantly to the trainee.

This characteristic and its effects can be extraordinary. I have often witnessed top-level executives—perhaps first-time video users—watch themselves on the playback of the first runthrough of a presentation and give themselves a highly accurate critique of what was right and wrong about their on-camera appearances. Sometimes they only need to see a few minutes to undergo the internal reordering of perceptions that is critical to an executive's improved performance. Often the producer or trainer doesn't need to say much. The trainee sees all he or she needs to see—all through the videotape medium.

CASE STUDIES

Teaching Interpersonal Skills: Management of Human Resources

Stamford, CT-based MOHR (Management of Human Resources) provides training programs to corporations that involve inter-personal skills: sales, management performance, interviewing techniques, negotiating, customer service.

MOHR's method of teaching reflects the fact that corporate training environments are multi-media oriented—training is achieved through a variety of print, film and electronic media.

According to MOHR President Herb Cohen, "Video demonstrations are integrated into the training programs. Our method of teaching is called behavior modelling which is based on Albert Bandura's social learning theory. First, we demonstrate, model the behavior we want the trainee to learn. Then remediating principles are demonstrated throughout the video modelling programs, and there are several pencil and paper exercises (including trainee participation workbooks).

"We believe the video demonstration should match very heavily to the target population. They should see problems that they are normally faced with on a regular basis successfully demonstrated by a supervisor or salesperson.

"Then we go into role play; we call it rehearsal, skill practice. What we advocate is to videotape those rehearsals so that we can guide them through the interactions. They role play a real situation from their direct experience. After the role play the facilitator replays the videotape stopping at appropriate times to show good examples of interaction and missed opportunities.

"So we use videotape to (1) demonstrate the interpersonal skill, (2) model an entire interaction, and (3) rehearse a role play situation."

Interactive Video Role Playing: Performax

Southport, CT-based Performax, Inc. has developed an interactive video system for role playing. The essence of the simulation training is a "live conversation" between a trainee and a pre-programmed partner who appears on the video monitor. The trainee, in effect, conducts a role

play with the on-screen partner who presents a typical problem situation. Both sides of this dialogue are recorded on videotape and can be played back for self-evaluation.

According to John Barwick, president of Performax: "The problem with role playing is instructor time. It's a very inefficient way to teach anybody anything. It's one-on-one: one instructor for one trainee. You're really involved in a behavioral change goal.

"To really affect that requires a large amount of practice. A trainee can role play something once, but he's usually too nervous; the anxiety factor is too high for him to really simulate and absorb what it is he is trying to do. He needs repeated attempts. This would be the case with almost any physical or motor skill.

"Repeated practice attempts are exactly what his instructor or any other role player can't do. They might go through it once but they are rarely able to look through it more than once. Or if they do it more than once, they can't do it the same way twice. Nor do they find it easy to imitate the styles or characteristics of the different types of interpersonal problems that the trainee is learning how to deal with.

"So for all these reasons, role playing is perceived as being effective. It's just that it's not very efficient.

"Some years ago when video technology and computers began to merge, I felt it ought to be possible to reproduce the characteristics of a role play situation using technology. We began to think of the training process in terms of a simulation. We would simulate the customer environment and the customer himself, but he'd be in the television set, on the screen. And it would present to the trainee all of the standard problems the trainee would encounter if he were dealing with him live.

"In that situation we would provide opportunities for the trainee to respond appropriately or do whatever was called for at that point. You would consider the person on the screen as a conversational partner.

"The dialogue would be automatically videotaped with a semi-concealed camera and a VTR. When any particular episode was finished, the trainee could go back and, as a semi-objective observer, could see himself on the screen engaged in dialogue with this target.

"Usually the first attempts are pretty rugged. It takes people a little while to get used to the system, just as it would in an initial sales call, to get the vocabulary under control and learn how to respond in a smooth professional way.

"Since the trainee has an unlimited number of practice attempts with the prerecorded customer, it's a complete self-study situation. No one, no other supervisor, no classmate, nobody else is watching at this point, so the anxiety factor almost disappears entirely.

"With the Level III touch-screen system, the trainee can touch the screen when he's finished. When he touches the screen, the camera and VTR shuts off and now the customer, who's on videodisc, will respond. Another system is voice-activated. When the trainee's voice stops, the customer comes back automatically. In that case there's no physical contact between the trainee and the screen.

"The playback is quite remarkable, because you see what looks like a totally seamless conversation."

Decentralized Role Playing: The Prudential Way

Prudential Insurance, the largest and one of the oldest insurance companies in the United States, has been using videotape role plays for many years.

According to Alan Eisenberg, Manager of Audio/Visual Training for the Prudential, "Quite an extensive experiment was done with putting video in the Prudential because of the expense at the time. I think Sony brought their VCR in here as soon as it was invented in the early 70's. People were quite interested.

"Between 1971 and 1975 people were talking about the possibilities . . . training, the press and everybody else, and how we were going to learn with videocassettes.

"Finally in 1975 a two-year test was put together. What was learned during that test was that role play training is definitely a plus. When the television set was in the district, without the role play training, learning—as measured by how successful agents were—was *less* effective than nothing at all. It was only when the TV and the pre-

programmed instruction along with the role play training was done, that we showed a real benefit.

"In the beginning, the tripods were very hard to use. The camera was very heavy. If you used those things for a while, it began to give a very low-contrast picture. It was a horrible picture."

Today, Prudential's use of videotape for employee communications is extensive. The company has between 21,000 and 22,000 people in its salesforce in about 1,150 offices.

According to Eisenberg, "Basically it is used for sales training. With respect to role playing, many different skills can be practiced in which the learner can benefit by seeing his performance. It works well with anything that involves verbal skills because there is so much going on other than talking: what you look like while you're talking, what you're doing with your hands, body motions, etc. This is important for an agent learning to sell effectively in front of individuals.

"The instructor has to be a very good psychologist and pretty enthusiastic. It's so much easier to set up now, we're finding that good sales managers will use it, and use it effectively.

"You have to have someone who can manage it and know what the principles are and what you're trying to accomplish. Until someone is really proficient, just thinking in terms of a presentation, they should have quite a degree of skill before going on camera.

"The way to achieve it is to do it in little bites. To pick out certain segments, segment the presentation. Do a little bit at a time and do it right.

"Just to go on camera just for the sake of it, I think, can be very jarring. Or if you start using it too soon or you start using it with the wrong kind of coach. It depends on the personalities. Somebody who is not afraid to look at himself critically and make changes is fantastic and may not even need a manager. Somebody has to decide what those personalities are.

"Generally, you get people who have no problem with public speaking; they'll look at themselves and you'll get extremely positive

feedback. But those who aren't so hot are going to fall down as much as that other person is lifted up. There are people out there who should probably never go on camera. It's really up to someone to manage it effectively."

PROGRAM DEVELOPMENT GUIDELINES

Following is a distillation of what users have said about the use of videotape for role playing:

Keep the size of the role play group small

Practice seems to recommend small groups of from 6-12 individuals. The consensus on how many people should participate in a role play at any one time is three. The third person serves the role of observer, while the other two play seller and buyer, for example. After, all three rotate roles.

Provide a professional role playing training staff

An instructor should be present. Professionalism is a strong issue here: instructors must use tact, while at the same time moving the trainee forward in the learning situation. The trainer has to be gentle in his criticisms of the recruits' mannerisms. The instant replay mirror image can have a traumatic effect on a recruit if the trainer is not tactful in pointing out areas where improvement is needed.

Defuse student anxiety

Trainers should, in some way, "prepare" students before they role play before the camera. This may range from having students do anything they want before the camera, to dry runs that are not critiqued, to exercises in self-critiquing, to assuring the student that the tapes would not be used for anything more than the role playing session. Repeatedly point out that everyone in this kind of situation tends to be hypercritical of his own performance and stress the positive aspects of participants' behavior. After proving to the trainee that video is harmless, explain your objective. Let the trainee know what you are trying to accomplish, and how it will benefit him. Drive home the point that the tapes they make will *not* be kept. Gain their confidence by letting them see that their performance on TV will be "erased."

The technology should be transparent

Videotape technicians should be transparent. In many modern role play environments the recording technology is hidden from view (in earlier times, the equipment was in full view). The VTR operator and cameraman must also be cooperative and sensitive to the impact videotape recording has on the trainee. Remarks from a cameraman, while intended to be humorous, might not be appreciated and may create apprehension where none had been present.

Limit the length of the role play sessions.

To be effective, a role play session should last from a few minutes to no more than 15 or 20 minutes.

There are two reasons for limiting the length of the session. First, for learning effectiveness, the role play will have to be played back. The longer the role play, the longer the playback. Second, the longer the playback the greater the amount of feedback that will need to be given. For effectiveness, each role play participant should gain insight into one or perhaps two points concerning interpersonal behavior or product knowledge delivery. More than this at one sitting and the trainee might go into "information overload." Thus, limiting the length of the role play also limits to small doses the length of the playback and the feedback.

Don't take equipment for granted

A major consideration with respect to equipment is its quality, flexibility, and low incidence of maintenance. In the main, users have been willing to settle for black and white cameras, given the greater expense of color cameras. Even so, the equipment should not be taken for granted. Check all equipment in advance to see that it's in working order, and check it enough in advance to order a replacement for faulty equipment. It's best to bring your own equipment along with trained people to run it. If you're entering a program of regular meetings, it's wise to invest in high quality equipment.

Review the trainee's progress

Trainees should have enough opportunities to role play that progress can be seen and noted. Play back just the video portion (without audio)

for training effectiveness. Perhaps the best critique comes from the trainee himself, reinforced by the trainer and others present at the session.

One of the most important aspects of role playing with videotape is that the trainee has an opportunity to see the progress made via before-and-after situations. For example, a salesman completes a seven-minute detail and reviews himself on the monitor, first with both audio and video, then again with just the video portion. Ask him to take note of any facial or physical gestures he has made that are hostile. When the monitor is placed beside a mirror, he or she can study the "before" and "after" image simultaneously.

Another method of comparative learning can be invaluable in guiding students to the desired goals. For example, a student makes her videotape debut while introducing herself to the class. The tape is played back after the calls, and each trainee is asked to analyze her video image. Only the trainer and the recruit are present in the room during the role playing session, and the tapes are shown only to the recruit.

Use pre-recorded tapes as behavior role models

Pre-recorded videotapes are used to give trainees role models in anticipation of the role plays that follow. Selling situations are demonstrated in short scenes on videotape; the skills of a complete sales call are illustrated. The salesman then views a pre-recorded videotape in order to analyze different presentation techniques that could be used in the subsequent role plays. Each role play performance is preceded by an analysis of a video presentation which illustrates the different selling techniques needed and also updates the salesman's product knowledge.

SUMMARY

It is likely that videotape as a role playing training tool will continue to serve corporate managers for many years to come. Whether it is videotape or perhaps one day a recordable CD or videodisc, the technological ability to record a person's behavior and interaction with others almost immediately after a role-playing session will continue to underscore video's benefit of serving as an "electronic mirror."

8

Management Video: Executives Get into the Act

SENDERS AND RECEIVERS

Since the early 1970s, top management has used video for communicating with other high level executives and middle managers at multi-locations. As a result, not only has top management gotten into the video management communications act, is has become the act.

Top level executives had rarely used mass media (such as radio and broadcast television) to communicate with the rank and file. Managerial practice was more militaristic and bureaucratic. Chain of command through paper (policy statement, manuals) and face-to-face communication (periodic staff meetings) was the norm. The videocassette helped change all that. Videocassette technology, together with other electronic communications devices such as the computer, telephone and satellites (which has spawned the business television industry), have *collectively* contributed to the changed nature of corporate management in the last 30 years.

No longer can top level managers issue edicts from cushioned and isolated corporate headquarters towers. Top level management today

must have expeditious communication with a variety of internal and external publics, each of which has specific informational demands. Video(tape) is part of the various media networks corporate managers now use to communicate primarily with internal management publics.

THE BENEFITS OF VIDEO FOR MANAGEMENT COMMUNICATIONS

The use of video for internal management communications in the last 20 years strongly suggests the medium offers specific benefits.

First, the medium has *speed.* Videotaped messages can be shot, edited, duplicated and distributed in days to a domestic and/or international employee audience. (Not all programs produced at this rate of speed will have the professional look or depth of content of a *Nightline.* There are differences in content, of course, and, more importantly, there are vast differences in the number of people working on *Nightline* and (potentially) on a management communications video; probably on the order of 50 to 1.)

Second, the video medium has *credibility.* Television today is perceived as the medium for news. If you're seen on television you gain at least exposure, if not credibility. Today's corporate communication environment virtually demands that executives use the television medium as one major means of communicating with employees. As I stated in Chapter I, executives may not be able to shake the hand of everyone in the corporation, but video is "the next best thing."

Third, videotape's look of *immediacy* (as opposed to the look of film and even high definition television) gives the viewer the impression that the executive presentation is live, present and directed at the viewer. Videotape, therefore, gives an employee the feeling that the executive is making a connection with the employee.

CASE STUDIES

Management Perspectives: Hewlett Packard

Hewlett Packard started a management-to-management communica-tions show in 1986 called "Management Perspectives." Brad Whitworth, manager of employee communications (corporate public relations department) says, "It's pretty flexible in format. It comes out about four

times a year. It can be anything from a one-on-one with the CEO and President to a panel discussion with a number of top managers.

"The intended audience is at least first line supervisors, middle managers and up within Hewlett Packard; which is a pretty broad audience. You're looking at at least 3,000-4,000 people; maybe more than that worldwide."

Hewlett-Packard has 70 plant sites and 120 sales offices in the United States, and another 200 sales offices and factories in Europe and throughout the Far East and Latin America.

"One of the most successful programs is our annual recap of the general managers' meeting. We bring in the top 190 managers from around the world for two days of sharing best practices; hearing what last year was like; what the year ahead is shaping up to be. The audience hears a little bit about the directors and top management concerns.

"We take some of the presentations and boil them down into 20-30 second sound bites combined with one-on-one interviews with some of the key people who were there and have general reportage of the event. We produce this as a tool for the managers who were able to get to this meeting; they can in turn take this tape and, along with notes, do an adequate job of sharing what they were exposed to with their employees.

"If nothing else we are encouraging managers to make sure they are talking to their people; giving them a tool with some consistency of message (we know a baseline of information is made); and at the same time not take away from them the honor, the necessity of them communicating what it is they learned.

"We aim for about 15-20 minutes maximum length. That's about how long we can keep someone's attention. It has gone as long as 30 minutes for more in-depth kinds of presentations. If we had panel discussions or customer interviews, it became a little more elaborate production.

"The biggest piece of advice I have for others producing management-to-management videos is to make sure that whatever you do fits in nicely with the culture and other existing communication channels.

"We didn't start this program in a vacuum. We've had a management newsletter for a while and there was a clearly defined niche for this

newsletter: to try and warn people about things that were coming down the pipe and describe the things that will affect managers in the next 6 months or so. In that print process, for example, we will talk about the formation of a new workforce; we'll talk about a piece of legislation that might be moving through the governmental body.

"As part of the early warning system, we felt the video counterpart could deal with things on a more real time basis. The implications of some major pronouncements; something like the general managers' meeting.

"So instead of a newsletter to tip people off to things that might be happening, the video program was positioned properly as a tool which helps explain some of the changes as they arrive, once they are there. So the best advice is: figure out what your objectives are; its mission; and how you position this video tool because it can serve a variety of purposes.

"We have an internal rate card. Most of these are in-studio kinds of things . . . usually studio charges and tape duplication runs us about $10,000-$15,000. If I had to pay an outside vendor, my hunch is I'd have to pay about double that.

"I'm usually the moderator, so I end up having to write scripts. Much of it really depends on the format. If it's an in-studio program, what I'll do is say to my four people on a panel, 'Here are the kinds of questions I'm going to ask.'

"They'll usually go off and think about it and scribble a few notes on the points they want to make. But it tends to be very loose.

"We can always go back and do a little editing. For instance, during our general managers' meeting, I'm taking mad notes of the things which we're going to use; the sound bites from people standing behind the podium which are few and far between and then where I'm going to have to supplement by grabbing this person for an interview and that person for an interview and then what information is best conveyed by the host of the program. So I'm writing my voiceovers; I'm figuring out what questions to work into an interview; I'm also picking the sound bites to use. Graphics are all done in post-production.

"We've always had the capability for doing the production, but we are off in the distribution—making sure someone at the far end can

pretty much guarantee the thing will be used. And we're at an advantage over other places because we have a communications manager at most of our major sites. And rather than send a tape to a manager and assume that he or she is going to get everyone together to watch it, what we'll do is get the program into the hands of the deadline-oriented/action-oriented communications manager and say: 'Please make sure it is seen by this audience.' And that seems to increase the viewership levels tremendously."

Keeping 400 Informed: At Ford

About every three years, roughly 400 of Ford's top executives from around the world are brought in for a week's meeting. They are immersed in the strategic issues facing the company. There are break-out meetings and people get very involved. Then they go back to their respective jobs.

The problem for Ford at a 1988 meeting in Tucson, AZ was: how to keep these 400 top executives up-to-date on various issues facing the company on a global basis.

According to Ray Anderson, manager, management communications planning department, corporate public affairs: "That's why my function was set up—to keep this top 400 informed. Which in reality is about 2,000 people, well below 1% of the company's salaried employment.

"I communicate with the top 2000 managers around the world for Ford, with video and newsletters. (The first newsletter I did was published almost in its entirety in the *Financial Times,* so I'm not pressed for anything that would be terribly confidential.)

"Typically, a video involves the chairman, the president and maybe the chairman of Ford in Europe, addressing different aspects of an issue. Maybe it's a strategic issue. I've done communications on what our position is on the environment globally. One of the things we try to get is a consistent thought or a mind set.

"We produce this programming as needed. For the first quarter or six months, I didn't do a management communications video because we were focusing on getting Harold Poling established as the chairman. Then this summer, I went back into business. Then, I'll back off and maybe do something like the state of the company.

"The 30-60 minute programs are distributed to a worldwide audience: places where we have major operations like Taiwan, Australia, the United Kingdom, all of Europe.

"English language is not a problem. Most managers speak English. But you have to be aware of different meanings of certain words like 'redundant.' It means something different in the United Kingdom than it does in the United States. If I am aware there are going to be problems during the interview I'll say, 'Let's go back and put it in this tone.' I use a video guide to explain terminology.

"You can't do this kind of programming effectively if you don't have the cooperation of the company's top management, because you can have doors shut to you and it does absolutely no good. Harold Poling is very open, he's very candid, he'll tell you what's on his mind. At the same time he lets you go and do your own case and come back and tell him what you're going to do.

"When I'm doing a video presentation I never script the people that I'm interviewing. You want to get *their* impressions, not the speech writer's thought; you want the individual's thought."

PROGRAM DEVELOPMENT GUIDELINES

At a minimum, a management video should involve:

1. A statement of the program's objectives
2. A definition of the intended audience
3. A definition of the ultimate distribution of the program
4. A pre-production, production, and post-production schedule
5. A definition of any graphics, film footage or slides that may be needed
6. A proposed budget
7. An outline of the program's content in the order in which it is to be presented
8. A listing of those members of management who will participate in the program both in front of and behind the camera (e.g., subject experts)
9. A rehearsal schedule

While items 1-6 are de rigueur for any video production, items 7-8 present special considerations with respect to management video communications.

Outline the Program

Pre-plan the program in black and white. Doing this helps to preclude the error of putting too much content into one program.

The more successful management video programs are those that stick to a few specific subjects. Being able to "see" the program in the planning stage gives management and the producer a chance to cut the program down to size. Tapes not planned in this way tend to be long-winded, disjointed, and leave an audience confused by a mass of information. The objective is to create understanding through succinctness and clarity.

The organization of the program's content is equally important. Pre-outlining the program gives management and the producer opportunities to create logical transitions between subjects. All audiences appreciate a logical flow of information, even if it is not obvious. Management will also appreciate a logical sequence because it will be easier for them to perceive and absorb the total program. Moreover, managers should carry over this "understanding" of the total program into the rehearsal and final production stages. The end result should be a more relaxed, genuine, and effective management performance.

While all video programs need pre-production planning, it is of even more concern when management is involved, because management's time is at a premium. The more time spent in pre-production planning, the less time management has to spend "under the lights." The pre-planning process should take at least 60% of the time involved in producing the program. In some cases, the proportion of time devoted to pre-planning may be even higher.

Corporate network programmers who have produced management video programs have learned that management looks to the professional for expertise and guidance as well as constructive criticism. This need or desire may not be articulated directly, but it is there, and the producer must take the initiative by conveying to management the need for pre-planning.

The television production process should be as free of unnecessary distractions as possible. A relatively smooth production process can be a short term benefit of good pre-planning. The longer term benefits are less obvious but are crucial to the growth of video as an internal

communications tool. Management will understand that it takes time and effort to produce a successful video. Participation by management in the pre-planning and subsequent steps can create a positive environment for the development of future programs, especially if the process is approached on a professional and structured manner. Through this process, management should begin to understand video production is bigger than a breadbox, but smaller than a Cadillac—to produce an effective video program involves more than just setting up a camera and lights, but less than producing the Super Bowl.

Rehearse

Between the initial stages of planning and the actual shoot is a vital step that goes a long way towards satisfying everybody's objectives. This step is the rehearsal.

Some will say, "Why is there any need for management talent to rehearse? After all, they know what they're talking about, and as corporate executives it is presumed they enjoy some measure of verbal acumen."

Management personnel are, by their very position, corporate spokesmen. *Who* is communicating is as important as *what* is being communicated; moreover, the manner in which the content is communicated is crucial to communications success. And, of course, some executives are better communicators than others. Any well-planned message can become garbled if the person delivering the communication fumbles, mumbles and stumbles. The rehearsal can help reduce the chances of this occurring.

Another reason for using the rehearsal as a preparation technique is that management video programs can be valuable communications tools. Employee audiences are an important constituency with respect to the corporation's views on public issues such as equal employment opportunity, wage and price controls, environmental problems, government regulations and management/labor relations. Internal audiences can be a prime source of support for management's positions on these issues.

Ideally, management should view internal video communications in the same light as external broadcast communications, such as the *Today*

Show. (After all, before and after working hours, all employees become part of the "external public.") No audience, employees included, wants to see the "talent" (i.e., executive) uncomfortable in front of the camera. Executives who are unfamiliar with the television medium are uneasy in front of the camera during the first few productions; on the other hand, executives who have planned and rehearsed their programs come off looking more at home.

A third reason for rehearsing a corporate executive is to familiarize him or her with the video production environment. Many executives have had the experience of conducting meetings, giving speeches or making presentations to small groups of people, but talking into the glass eye of a television camera or being interviewed by someone else while "under the lights" can be unsettling. Rehearsing allows the executive to become accustomed to the video environment, in addition to letting him fine tune the content and organization of the information to be communicated.

Without a rehearsal the executive is put on the spot. Every fumble is exacerbated by the newness of the hardware, terminology, hot lights, cues, stops and starts associated with video production. The moment the uninitiated corporate executive steps in front of a television camera without the benefit of planning or a rehearsal, that executive undergoes a severe test of his or her self-esteem.

Everyone needs a period of transition from the unknown to the known before the "big event" for both mental and emotional reasons, and the rehearsal provides that transition.

Handle the expert diplomatically

Today, management respects the judgement of television producers. Producers are heavily involved in the content of the program.

But mediating between the communications needs of subject experts and the communications needs of intended audiences remains an inherent problem. You have to be careful with subject experts. Often they want to do an information dump. You have to make them realize you have a total communications package, that you use various media tools, and that video is just one of them.

If the client gets the upper hand in producing the program, too much information will get on the videotape. The program will have too much information in it for the audience to assimilate.

How do you convince that subject expert that what he or she wants to say in that tape contains too much information? How do you satisfy the objectives of the subject expert while avoiding overstaying a video visit with the audience?

The most important thing is to know your medium, the production techniques, its communications capabilities, principles of cost-effectiveness, defining objectives, analyzing audiences, and so on. But this expertise is not worth the videotape you use to produce the program with unless *you regard the subject expert as a person.*

Let's look a little closer at this situation. A subject expert walks into your office and declares: "I think I want to produce a videotape. Can you help me?"

Probe your subject expert at this point and you will find he or she has just made a statement fraught with emotion. Why? It is basic human nature not to want to admit that one doesn't know something. Video, a sophisticated electronic communications tool, can be perceived by some as a potential threat to career survival. Ask any print-oriented training specialist or public relations professional. Lack of knowledge of how video works or how it should be approached can be intimidating. Thus, your subject expert will probably want to maintain control of the situation (i.e., the production) to keep from blurting out his inner hysteria.

What to do? At the beginning, let the subject expert do the talking.

Handling the subject expert is not unlike using the proven techniques of salesmanship. First, you have to sell yourself. But you cannot do that until you know something about your customer; in this case, the subject expert or executive. Once you have laid the foundation you can begin to sell your expertise, and reach the objective: satisfying the client's needs while at the same time meeting the audience's needs.

Being a communications ombudsman/diplomat means more than knowing how to produce: it also means being sensitive to the real human needs of your subject expert, as well as the audience's.

Edit to protect the executive

How far do you edit an executive's video presentation? Do you leave in all the "uh's" and "uhmm's" and statements like: "Gee, that's just great, Joe," or "Thank you, Joe?"

Or let's say you're in the editing session and you suddenly realize that what Corporate Director X just got through saying does not fit with what he says a few minutes later, or that his grammar is not right, or that he or she says something that is out of sequence with what the graphic says.

These are two sides to the issue. Some producers feel that "whatever they sound like, that's what they sound like." The flip side is that a little extra editing will make the executive sound better, and they won't know how much they were edited when they review the program. Content that is cut out is usually not missed. The material may have been irrelevant. The potential resolve to this issue is to work towards some kind of balance between preserving an executive's personality on the one hand and respecting the audience's informational needs on the other. The more preparation and rehearsal the less problematic this issue becomes.

Use cover shots to create pacing

When you do a lot of panel discussion programs you have to frequently use the cover shot. The cover shot is vitally important to the visual smoothness of the program and the visual continuity of the content.

Too often, however, the cover shot is limited to its most obvious function: either covering a jump cut, or breaking up the monotony of a long presentation. With better planning and rehearsal, there would not be such frequent use of the cover shot.

Most of the problems associated with cover shots stem from the fact that the editor (or producer or director) did not choose the cover shot material with a sense of "visual continuity." Case in point: Executive A is looking at Executive C across a table. There is an edit in the content (jump cut). Executive A continues to talk. Executive A's content at that point is of a serious matter. However, the cover shot of Executive C is inappropriate; Executive C looks like Executive A just made a humorous remark to which he is reacting by nodding his the head, and he is also looking in the wrong direction—at Executive D.

Another case: An edit is made in Executive A's content, resulting in another jump cut. The editor decides to use an over-the-shoulder cover shot. However, a fraction of a second before the cover shot, Executive A begins to raise his hand and turn his head to the right. When the cover shot comes in, the executive's hand is still on the table and his head is slightly turned to the left.

A little extra work at creating better pacing improves the flow. With computer editing systems working within parameters of 1/30th of a second, you can spend time previewing the edit and shift "edit ins and outs" until it looks right.

Use makeup to psychological advantage

In some cases, using a makeup person for management communications programs can be very successful, not because it makes managers look better on camera, but because the makeup person can do a marvelous job of warming up the non-professional talent before they get onto the set. Even with pre-planning and rehearsals, the presence of the makeup artist, the act of putting on the makeup and the preening of the non-professionals during a break in the shooting usually goes a long way to getting executives to relax and be themselves. It shows in the final product.

This is not to say a makeup person should be used all the time. If you're on location in the middle of a field, on top of mountain or in the bowels of a nuclear power station, the application of makeup may in fact detract by making superficial a real-life environment.

Use the teleprompter judiciously

Someone once said, "Only professionals should use a teleprompter." I used to agree, until I had the following experience. Several days earlier we had shot two shows involving personnel who report to a divisional vice-president. He was going to give separate introductions to each show even though some ideas were common to both. He had not been on television before. The intros were shot according to the advance outline his communications manager sent me. At the rehearsal, he had no problem with eye contact or delivery—but he had trouble saying what he wanted to say in an intelligible manner. I suggested different techniques, like putting an interviewer into the situation. That didn't work. Finally, it occurred to me that this executive needed to prepare his intro (2-3

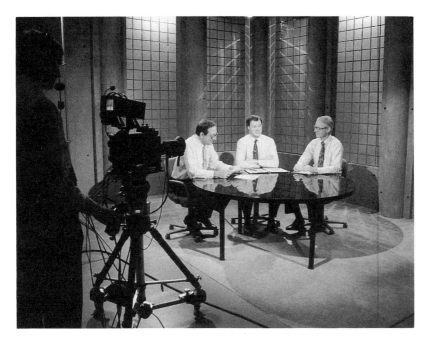

Figure 5: A set erected in the studio for an "executive chat" type of program. Photo courtesy Michael Danese, Air Products and Chemicals, Inc.

minutes long, at most) word-for-word. He also needed a teleprompter. A few days later we shot both intros using a teleprompter—in less than an hour.

When professionals use a teleprompter they make it look like they're speaking directly at you. Non-professionals need to practice before they get the hang of it. There are ways to speed up the process. One way is to have the person work individually with the teleprompter operator. This gives the executive a chance to warm up and makes him feel more in control of the situation. The manager can begin to get a reading pace, feel more relaxed, make minor adjustments in the script. While this might be annoying, the smart director will let these small changes pass unless the changes are substantive.

The executive should read through the entire teleprompter text once or twice. Then the director can try for a first take. It is usually not usable. Normally, after the executive gets through the first few paragraphs, the

reading pace becomes more natural, relaxed and more credible. It's usually wise to go back and have the executive re-do the opening.

Despite protestations to the contrary, all executives want to be directed and told what to do, even if it means saying something like "Speed up your reading pace by 10%." It is the producer/director's job to make the on-camera executive look as professional and personable on the screen as possible.

Use the executive as a reporter

Many programs in which top management communicates with field management use a straight into-the-camera technique, a roundtable discussion format—or a combination of the two.

The problem is that these formats do not allow for complete content flexibility. While pre-production meetings and rehearsals nail down 99% of the content, there is always the chance that someone will not use the right expression or exact statistic during the shoot. These errors may only be noticed in the pre-editing session.

Moreover, roundtable discussions can become "chatty" rather than to the point and succinct. The solution is to have the lead executive play the role of reporter. For example, after one or two minutes of exposition (e.g., annual sales, earnings, safety statistics, marketing goals), the lead executive may play the role of reporter by stating, "At a recent meeting of my staff, all these future goals were discussed. Present at the meeting were . . ." etc., etc., etc. By casting the executive in the role of reporter, the producer has a multitude of opportunities to edit the material so as to focus the content to a high degree.

If a major point was not made exactly clear at the round table, the executive-as-reporter can articulate the point. Because the opening, closing and voiceover transitions are written after the roundtable discussion, both client and producer can spend time finding the right words to say what has to be said. They can also collapse long-winded statements into short voiceover transitions and alter the structure of the roundtable discussion at will.

The result of this technique is shorter, more focused programs that keep management communications audiences attentive and leave them informed.

9

Employee Communications: Spreading the Word Electronically

The broadening use of videotape from a training medium in the late 1950s-mid 1960s to an employee communications medium is reflected in the corporate television studies published in the 1970s.

A 1973 study placed employee communications as the fourth highest application. The 1979 study found that "Orientation" (a form of employee communications) ranked second highest, with "Management Information" in third place. The 1980 ITVA study ranked "Employee Orientation" in third place, "Employee Information" in fifth place, and "Employee Benefits" in tenth place.

This use of the medium seems to satisfy a desire by management to reach *all* employees—not only at headquarters, but also in field locations.

The growing interest in videotape as a means of employee communications in the 1970s and into the 1980s is reflected in the results of a survey conducted by Ketchum MacLeod & Grove Public Relations at the International Conference of the International Association of Business Communications (IABC) in 1980. The IABC, at that time with an international membership of 6,800 organizational communicators, encompasses a wide spectrum of businesses, government agencies and nonprofit associations. The survey revealed a majority of the respondents were using videotape in various forms for employee communications. The medium's ability to visualize the subject, its adaptability to large or small groups and its flexibility were factors mentioned by respondents as positive attributes of the medium.

The use of videotape for employee orientation was cited by many. In many cases, tapes explaining company programs and benefits to new employees were produced for long-term use and updated when benefits or programs changed. Videotapes were also used for employee motivation and to explain general news about the company such as promotions, new acquisitions and new product lines. Employee news is also part of this category, but it has been given a separate chapter because of its unique use of videotape.

Other applications include safety information and special events, such as an open house or anniversary.

THE BENEFITS OF VIDEO FOR EMPLOYEE COMMUNICATIONS?

Why use videotape for employee communications?

In 1976, James R. Singleton, then publications officer for the marketing division of Bankers Trust (Columbia, South Carolina) wrote an article in *Educational & Industrial Television* entitled: "Thinking Television? Think Total Communications." He stated: "Too much of today's approach toward the use of AV and TV in business is geared toward training. Training use is great, but the key to today's corporate ballgame is communication—and this is true of all areas of industry."

Since the late 1960s, managers and producers have given two central reasons for the use of videotape for employee communications: cost-effectiveness and communications effectiveness.

For example, users have indicated it costs too much—in time and money—to bring all managers and supervisors together at one location and that such meetings are not always practical. Videotaped employee communication messages enable employees to participate in such meetings with executives from company headquarters, even though the experience is somewhat vicarious. In the 1990s, video employee communications has reverted in part to a live format (reprising the days of live broadcast television) with the advent of business television events: managers communicate live to various locations via a combination of television and satellite technologies.

Many companies have found that video hardware, in a hard-nosed cost comparison, demonstrates definite savings when used for presentations as opposed to slide-audiotape presentations. Other companies say that videotaped messages: "give employees a closer look at top executives;" "help relate field to home office;" "provide a good opportunity to get the whole picture;" and "give an overall view which would otherwise be difficult to grasp."

The feeling is so strong that managers and employees have stated: "All corporate employees should be made to see the tapes;" "I had never seen an annual shareholders meeting before and found it interesting and informative;" "especially enjoyed pictures of other plants;" "employees would enjoy hearing more about the various products and companies;" "more on shares and stock for employees;" and "will probably increase my savings and investment plan as a result of viewing the tapes."

The benefits of using videotape for employee communications are the same as those for management communications and marketing: videotape has speed, credibility, immediacy; it brings the event, the person, the place to the employee.

SENDERS AND RECEIVERS

The general employee communications application marks the first major instance in which top management becomes a presence in the use of videotape for corporate communications purposes. Moreover, it is clear that this application is a broader-based application (in terms of audience) than are training applications, with the following general breakdown:

Audience

All employees company-wide	41%
Select employees company-wide	41%
All employees at corporate headquarters	12%
Select external publics	6%

Following on from the apparent fact that the medium has a strong top management presence and a broad employee audience base, the location of audience indicated the same, as follows:

AUDIENCE LOCATION

Decentralized audience at multi-locations	86%
Centralized audience at corporate headquarters	7%
Centralized audience at regional centers	7%

Clearly, the advent of the videocassette has helped promulgate the use of videotape for this broad audience application. In fact, only one article on employee communications was published in 1970, one year before the commercial introduction of the 3/4-inch videocassette.

CASE STUDIES

Blue Cross/Blue Shield: Everything's Fine

In a program entitled "Everything's Fine: Adult Children of Alcoholics"—a production of the video division of Blue Cross/Blue Shield of Massachusetts (Boston)—Ed Asner narrates a 16:30-minute look at the impact of alcoholism and other addictions on family members throughout their lives.

The award-winning program's objectives were to: (1) identify the personality types who emerge from dysfunctional families; (2) understand that the behaviors appropriate for survival in a dysfunctional family may make adult life much more difficult; (3) explore the impact of adult/child behavior in the workplace; and (4) assist employees to understand that "Everything" doesn't have to be fine anymore.

According to Patricia Frieden-Brown, Manager of Vital Video (Blue Cross/Blue Shield's internal video production unit): "One of the reasons we did 'Everything's Fine' was that we did some research and we found that not only could we use the program for our own internal Employee

Assistance Program, but that we could also sell the program to external audiences across the country.

"What makes this program work is the drama, the fact that people could relate to it. This program took a year to make from beginning to end. It took about nine months to script. The hardest thing in the scripting process was that as we were doing the research we began to understand what the audience didn't understand. We quickly got beyond what the audience didn't know, but we had to hold ourselves back. We had to decide that this was an introductory program, the elementary program. This program was to help understand the concept of being an adult/child. The program is not a how-to program, how-to steps of how to get therapy or go through therapy. It's basically an awareness program."

The program shows five children playing together as a mock dysfunctional family. Later the five children are seen as adults and how they now act in various abusive ways: alcoholism, workaholism, drug abuse. Between the various scenes, Asner talks about how child feelings (suppressed in order to maintain the dysfunctional family's balance) can be destructive in adulthood.

"I've never had anyone see this program and not be affected by it in one way or another," says Brown. "To produce this kind of program you have to continuously think about the end-user. To be careful not to get too involved in the passion of the subject. When I was writing this program I had to continuously keep in front of me not what I wanted to tell the audience but what that person needed to know. So you keep the program condensed and understandable. And you keep it in a format so that the audience is able to receive the information. So you have to put your feelings and beliefs aside and do your research and stick to what that research says.

"Also, no matter how painful, keep your clients down to one thought or one point that an audience will walk away with at the end of the tape. Not two, four, ten points, not 15 different audiences that the videotape could possibly be addressing. But one particular audience. After the tape is made then you can look at it and say, 'Well, can it be modified?' But people come in and they say, 'Well we can use this as a marketing tape and a training tape.' You have to ask, 'What's your primary purpose? What's your primary thought?' and stay with it."

Catch The Spirit of Innovation: BASF

To encourage BASF carpet fiber industrial and commercial salespeople to sell more carpet, BASF produced a 6:30-minute sales performance incentive program entitled "Catch The Spirit of Innovation: BASF Fibers 1990 Incentive Program." It was initially sent out to BASF's carpet fiber regional sales offices in Dalton, GA and Williamsburg, VA.

The program dealt with the specifications, rules, regulations and other information pertaining to BASF's 1990 incentive program. For example, how many yards of carpet a salesperson had to sell of a particular product and what he would win after they reached certain sales goals.

According to William Orisich and Michael Pieprobon of the production company Big Picture, the award-winning program was effective because: "It contains just about every production technique ever invented in film. We had live action, stop motion, go-motion (animating an inanimate object), cut-out animation, rotoscoped animation. It's several minutes of sheer mania. It's a fun piece to look at. Visually there's no way you can look at the program and not get sucked into it. It's non-stop.

"The program was mostly graphics, although we did have some dramatic live-action sequences, like an old Bogie, detective style scene."

The $75,000 program was originated in 16mm and 35mm film and edited on tape. According to Pieprobon: "From a corporate and industrial viewpoint this is a little unusual. Film seems to be going through as big comeback phase right now. Five, ten years ago our corporate clients were a different generation. Now the people who are just entering the purchasing end of corporate communications are initiating corporate communications. That generation has grown up watching MTV and it's a much more visually sophisticated generation that is buying corporate communications right now.

"There's a certain look that they both like and understand that speaks to the viewer in such a way as to command more attention. Part of that look is the look of film.

"Two or three years ago our production ratios were running 80% video and 20% film origination. As of 1990 we're producing probably 75% film origination and 25% video."

Big Picture's approach to producing corporate television programming is "the sky's the limit." Says Pieprobon: "Just a few years ago we all had such a sense of corporate do's and don'ts, what was considered mainline, what was considered radical. That has changed drastically in the last two or three years. When we approach a corporate project the sky's the limit. The BASF program is the kind you would never see produced four or five years ago."

What has made the difference? "Corporate communications purchasers today understand television and they are not only open to newer, fresher ideas, but they're demanding it."

PROGRAM DEVELOPMENT GUIDELINES

Users have articulated three areas of concern regarding employee communications. They are:

- Production styles
- Handling professional and non-professional talent
- Use of the program in the field

The emphasis by users is on the program itself, as opposed to the use of the program once it is distributed to the field.

Looking at this application and the three training applications, it seems clear there is an inverse relationship operating. The more narrow the application from a user and audience point-of-view, the *greater* the number of reasons and programming guidelines for that application; whereas, the more top management is involved and the broader the audience distribution, the *narrower* the number of reasons for using the medium and the number of programming guidelines.

The three areas of concern can be translated into the following program development guidelines, as follows:

Orientation programs should orient, not overload

There is a natural tendency on the part of managers and subject experts to try and get everything into one video.

Of course, this doesn't work. As with other applications, shorter is usually better than longer. Orientation programs should give the new

employee a direction. It takes time for an employee to become fully oriented to a new organization and this should be taken into consideration when designing an orientation video.

The first step is to decide what a new employee needs to know for the immediate future. Next, translate this content into a style of presentation that allows for the most efficient delivery of that information. In my experience, a talking head, such as a personnel relations expert, doesn't hack it. It is better to have the program introduced (for no more than 60 seconds) by someone from top management, followed by a 10-12 minute "graphic" orientation to the company's operation, personnel, plants, products, customers, etc.

Employee benefits videos should impart central benefits, not every detail

Employee benefits videos present potential legal problems. If a benefits video conveys a legally inconsistent point, it could spell trouble for the employee benefits department and the program's producer.

This is one reason why benefits videos should only convey the central benefits of the company's array of benefits programs. This is a perfect example of how video and print work in tandem. The video is the open door for the employee to the benefits information. The print version of the benefits provides the details which, in all likelihood, will change over time.

Further, benefits videos should be produced as a library: one on insurance, others on major medical, dental, retirement, long-term disability, savings programs, etc. It might be worthwhile to produce one program that generalizes all the benefits programs.

Again, as always, shorter is usually better than longer. Don't dwell. Don't get cute. Visualize everything. Present the information in as stylish but straightforward a manner as possible.

Pre-production planning for special events programming is an absolute necessity

Occasionally, a special event occurs that management wishes to share with employees at large and/or certain external publics. One such event is the annual stockholders meeting.

By law each publicly held company is required to hold a meeting of its stockholders once a year. Depending on the company, such annual gatherings range from "ho hum" to "very stimulating." They are sometimes simple, short and sweet, or are accompanied by spectacular media presentations and/or intricate systems that stockholders both in and out of the hall can use to converse with the executives on the dias.

The annual stockholders meeting presents an ideal video communications opportunity: An opportunity to package information about the company for dissemination to a larger employee (and sometimes community) public. This event can be distributed live via satellite or repackaged on tape for later dissemination.

However, the road to a successful videotape on the annual stockholders' meeting is sometimes strewn with hidden land mines.

Keep in mind that the people who choose the place for the annual meeting may not be cognizant of the meeting's technical requirements— not only video, but other technical aspects such as microphone placement and audio control, multi-media presentations, seating arrangements, house light control, security, etc. If you will videotape the meeting, seek out the individual who will choose the site, and make your voice heard as to what kind of hall would accommodate an annual meeting from a "technical" point of view.

Next, visit the hall. On your first visit meet the person in charge of the hall and the technical personnel who you have to cooperate with in order to accomplish your production task. This is especially important if the meeting will be held outside the company's headquarters building.

Immediately after your first visit, make plans—literally, that is. Obtain a scale drawing of the hall and begin to ask questions: where will the lights go, and how will they be hung, where will they be controlled from, is there sufficient power for lights, where shall we put camera one, camera two, camera three, where shall we position microphones in the audience for stockholders to ask questions, does the hall have a public address system, how will this system tie-in to the video audio system, how can we rig the video audio system to serve as a backup for the hall's public address system, where is the hall's public address system controlled from, how will a multi-media presentation be shown, does the hall have the capability for front or rear screen, who shall provide the dressing for the hall, will we require additional draping, shall we dress

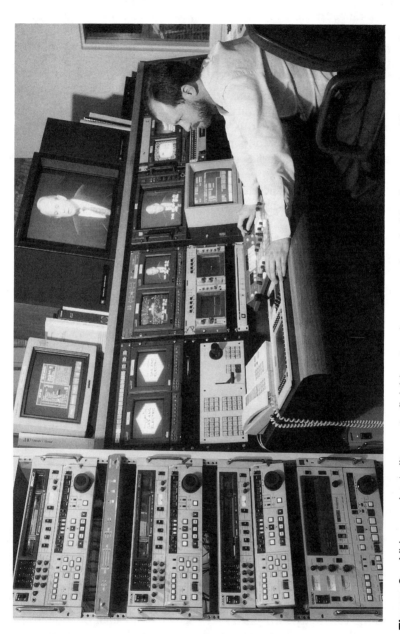

Figure 6: Videographer/editor puts finishing touches on a shareholders' program. Photo shows Sony Betacam editing system and Ampex ADO-100. Photo courtesy Baltimore Gas and Electric Company.

the dias tables, who will decide on the colors of the dressing, will we be able to use our own personnel to run audio, lights, video and multi-media, or must we use the hall's personnel, or a combination of inside and outside personnel?

Once these questions have been answered, the next step is to coordinate the answers with whoever is responsible for the meeting. If you are part of that team, terrific; if you're not, become part of it.

Several weeks before the meeting visit the location once more, primarily to make sure that everything you saw a few months back is still there, and to meet any new faces you'll have to deal with once you show up with your crew.

As the meeting date approaches double and triple check everything: personnel, equipment, plans, outside vendor commitments, hall personnel commitments. Then run down your checklist once more.

Now comes the meeting. Be the first at the hall for the setup to insure your technical requirements are taken care of. You might want to start setting up in the hall one or even two days before the meeting.

This planning and preparation can have the net effect of getting what you want on videotape without getting in the way of the meeting. For example, if you're still setting up lights 30 minutes before the meeting begins, you might get a reactions from the chairman of the board such as: "Hey, those lights are very bright, turn 'em off." Unless you've got super cameras for the occasion that work with very little light, you might as well pack up and go back to the editing room to work on another program.

Speaking of "program," what will you do with the one to three hours of tape of the meeting? Some companies show the meeting in its entirety to employees; others just the highlights. My preference is towards the latter. Unless the meeting was filled with highly new and exciting information (such as a new research and development product, a dramatic expansion of a market that will give everyone an immediate 5-10% raise), or the questions from stockholders were uniformly penetrating, incisive and stimulating, more than likely you will bore your audience by showing the whole meeting. Most annual stockholders meetings are "fair" in terms of content and excitement. A short (10-20 minute) "highlights" version of the meeting, using a news, voiceover,

narrator technique to introduce, bridge, condense, and highlight content, might be the technique required.

The style of this kind of videotape is especially crucial, because while the annual stockholders' meeting is an important event, it is of only mild immediate and direct interest to most employees (unless the content of the meeting is highly controversial).

The rationale for all this planning, execution, and editing should be to take advantage of an event that happens only once a year, during which top company executives look at the immediate past, talk about the present, and state goals for the future. Stockholders could well ask questions about the company's affairs that employees might have wanted to ask themselves.

The production quality of the employee communications program should be a reflection of the executives and subject experts appearing in it

This application usually includes a host of top management on-camera participants. While this kind of "talent" creates an inherent "audience interest" in the program, it is also true top management should not be made to look foolish, e.g., poor camera angles, bad lighting, sloppy audio, unflattering sets, lack of rehearsal, no tele-prompter, an uncomfortable interviewer, etc.

Every effort should be made to make the executive look as comfortable in the video environment as possible. Lighting should be flattering, but not obtrusive. The director should be comfortable working with top management and not intimidated by rank. At all times, the director must be in charge without becoming a video production "dictator." Tact is required throughout. Use makeup judiciously. Whatever it takes, the executive must look good in the final product. He or she must look comfortable, relaxed, credible, articulate, personable, and human.

This result is not always achievable. Some top executives just aren't good in front of the television camera. If this is the case, find another method for getting them into the program. Perhaps an interview approach would be better than a direct-to-the-camera presentation. Sometimes a narrator is useful to bridge statements by the executive. This is especially relevant when reporting on the happenings at an annual meeting, for example. Keep the executive's remarks as brief as

possible. A top executive draws a certain amount of initial respect when first appearing on camera. But that respect will fade very quickly if the presentation goes beyond the limits of an audiences' patience or believability.

Integrate material shot on location with material shot in the studio, and rely on graphics, as much as possible. When an executive is talking about statistics, product, places, events, or abstract concepts, for example, show it graphically. When, however, the executive is communicating personal anecdotes, keep him or her on camera. Mixing the two styles can be very effective.

Do not fall into the trap of being coerced into using a top executive just because someone said to do it. There must be an inherent production reason for including the executive in the program. If none can be found, then don't do it. A benefits program doesn't *have* to include a member of top management for the program to be effective.

The program's production style should fit the content intended to be conveyed

The use of top management in a general employee communications program must be carefully decided: if the executive doesn't belong, he or she doesn't belong. Make the choice early. When the audience tells you it was wrong (i.e., boring, unbelievable, too long, a waste of time), it is too late.

Prepare talent before shooting begins

Both professional and non-professional on-camera talent need to be prepared. In the case of professionals, this could take several forms. First, if a program is pre-scripted, actors and actresses should be familiar with the script. Preferably, the on-camera professionals should have copies of the latest version of the script days if not a week or two before production begins.

Second, on-camera professionals should be given an opportunity to have an overall understanding of the program. A read-through with the actors is very helpful. A scene-by-scene rehearsal is mandatory. Preparing on-camera talent before the crew arrives and is ready to shoot insures a more efficient production, a more efficient editing session, and a more effective finished program.

Non-professionals should be given the same considerations. A pre-interview with the executive should take place: e.g., what do they want to talk about, in what order, how can the ideas be best presented? This step should take place before the final script is created. Very often, this executive presentation will be edited several times before it is satisfactory to both the on-camera talent and from a television point of view. Don't be surprised if copy is edited at the time of the shoot itself. Be flexible. If you have an electronic lens-line teleprompter, the job of editing the copy on your feet will be that much easier.

A rehearsal of the non-professionals' part in the program should be accomplished before actual production, if possible. Here the major problem is inherent: the non-professional—top executive, subject expert—is by definition a television non-professional. Television coaching may be very useful here. An outside professional can be very effective.

Insure the use of the program in the field

One way to insure that the program will be shown in field locations is to gain support for the program from field management. This might mean department managers, regional managers, supervisors, plant managers. Some level of management at the field location must be aware of the program and be motivated to show it in the proper context.

One way to create interest is to announce the program's availability through signs in employees areas such as elevators and bulletin boards, notes in the house organ, flyers, table cards in the cafeteria, and memos.

The timing of the program's showing is also important. Several showings may be required: for regular staff, for part-time staff, for day-worker and night workers.

The physical viewing environment can help insure that the program is viewed by a broad audience. It may be necessary to show the program via a rolling cart that is moved around. Very often the program will have to be brought to the audience (as in an assembly line situation) where employees cannot leave their work environment.

A combination of viewing locations may have to be used: both fixed and portable. In some companies a master antenna system has been built with one central video player and several monitors located in employee

areas (such as the cafeteria, various work stations, meeting rooms) with the program played continuously at various times.

A local manager's participation in the showing of the program can in turn insure the proper viewing environment. For example, if the program is shown during a staff meeting, the supervisor can lead a discussion of the content and insure that the program's content was conveyed effectively. In some cases, a program may be shown several times for effectiveness.

10

Employee News: The Electrovisual House Organ

No other use of videotape for corporate communications purposes has attracted more attention from the consumer and trade press than *employee news*—perhaps because it most closely resembles "electronic journalism."

SENDERS AND RECEIVERS

Most management users of video employee news programming are public affairs or corporate communications departments. Audiences for this kind of programming are employees at headquarters, regional offices, or all employees company-wide (domestic and international). Viewing is done on portable equipment in a variety of locations, in special viewing rooms, and occasionally at home. Companies have also put their employee news shows on 1/2-inch players on rolling stands in some unusual places—not only in offices, but in switch rooms, garages, work sheds, and coal yards.

Some quarterly news programs are shown continuously in cafeterias during the noon hour. Most employees catch it going to or from lunch.

(Some people complain that the program disturbs those who prefer not to listen to or watch it. One company solved this by building a little theater around the television set in one location, and by putting the set in an alcove in the other location. Thus the sound was not directed straight into the main lounging areas.)

In other companies the news program is updated weekly and runs on the monitors for two days, usually between 11:30 a.m. and 2 p.m., when the cafeteria is open for lunch. Still other companies have placed monitors in heavily trafficked areas just outside the company cafeteria. Many employee news shows are also available to night-shift workers.

THE BENEFITS OF VIDEO FOR EMPLOYEE NEWS

There are two primary reasons why corporate management uses television for employee news:

- Communications effective
- Improves employee morale

Since the first reported use of video for employee news by Smith Kline & French in the late 1960s, companies have indicated that using video for employee news is more communications-effective than using film, and, in some cases, more communications-effective than using print.

Today it seems absurd to be considering film as a viable alternative to video. (In the mid-1980s it became clear that film was not growing as a corporate communications medium.) In fact, it is only because video-tape is a fast turnaround technology, with characteristics of immediacy and intimacy, that television employee news shows exist at all! The very existence of videotape and television provide corporate managements with the *opportunity* to communicate electronically with employees on a more or less regular basis.

Television's inherent characteristics allow management to communicate information in a way that is different from the content and style of "print" employee news format. When a chief executive officer makes a statement on video, it is more alive, more direct, more personal, and more credible. The television camera does not lie. People "feel" people via television. Television communicates on an emotional, visceral level.

On the other hand, television is not very good at communicating details or facts that can be reviewed "at will." A print piece can be studied, analyzed, and reviewed at the viewer's discretion.

It is a mixed media world: print and television work side-by-side in a multi-media communications environment. The perception of corporate users that video is more communications-effective than print must be understood from the point of view that video does *some* things better than print, but the reverse is also true.

Employee news television programming is one example of the changes in employee-management relations in the last decade or so. It provides employees with the view there is a more "open" communications environment.

CASE STUDIES

"Directions:" AT&T

Between 1983 and 1989, AT&T (Basking Ridge, NJ) produced a quarterly and then a bi-monthly employee news program for its 300,000 worldwide employees—from the chief executive officer to the mail clerk.

According to executive producer Christopher Newton, who came on board with the program in early 1987, "Our goal was to reach 300,000 employees, but the distribution problems were large. We actually only reached 60,000 employees."

This award-winning 30-minute program focused on "people" for its content. Says Newton, "AT&T has a lot of business units: long distance telephone service, switches for telephone companies and computers, fax machines and on and on and on. The problem was always to find stories that would be of interest across that wide spectrum. We tended to focus on the human side of the company more than the technological side.

"The goal of 'Directions' was to build employee morale. It was never seen as a news vehicle per se. It was seen as a vehicle to help the employees feel pride in the company. And it began at a time after divestiture when morale at the company was pretty low. The program was always seen as way to celebrate our heroes."

Each 30-minute program usually consisted of five segments. "We differed from the typical employee news program in that we never used an on-camera corporate host. We used a voice-over announcer who had a recognizable news radio voice. So he had a credible news voice."

What made this program an award-winner? Says Newton: "It was clearly our ability to truly build employee morale. Anyone who saw it said, 'My God, what a company that is. And they sure got great people working for it.' For example, the last program opened with a classic AT&T-to-the-rescue kind of a story. It looked at the aftermath of Hurricane Hugo that had happened on the coast of North Carolina in 1989 by telling with some very dramatic, powerful footage (that we bought from a local news station) the story of the hurricane and the impact AT&T service had on some of the businesses down there and the hospitals, police stations, those who had managed to stay open because their phone service had stayed up during the hurricane.

"After that we did a techie kind of a story: a new computer called the Pixel Machine, a high-graphic supercomputer used primarily for scientific purposes to imagine 4-dimensional realities using abstract math. This segment had terrific graphics.

"Another segment was the goodbye segment. This was the final edition of 'Directions'. It's no longer being produced. We said goodbye to our audience. We showed them a selection of their favorite stories over the years."

The program was produced almost exclusively by freelance producers with strong news documentary reels and a "feeling for people," working with Newton and a coordinator. Each producer supervised the production of individual segments. Newton supervised the "final, final" program.

The program is no longer being produced due to distribution problems. "The main lesson that I learned from the experience with 'Directions' is that it's not the quality of a program that makes or breaks a program. 'Directions' was a terrific program. We could not break the distribution barrier. We reached about 60,000 people. It's a lot of people, but it's only about 20% of the employee body and we really couldn't justify our existence on that basis. We just never found a successful way to reach an audience that's far flung around the world.

"I think that if we were going to do it again I would segment the program and aim it at individual business units and get those business units to finance it."

CASE STUDY

"Kaleidoscope:" Georgia-Pacific

"Kaleidoscope" is Georgia-Pacific's (Atlanta, GA) award-winning employee news program distributed to 300 locations.

While designed for salaried employees, all employees can have access to the program, including taking a copy home.

Out of 66,000 employees about 15-18,000 employees view the program. Approximately 75% of the distribution is on VHS, with the balance on 3/4-inch videocassette.

The quarterly program, which has been in production in its current format since 1984, went through a similar experience to that of AT&T's employee news show. It was temporarily put on hold for six months in 1990 until the beginning of 1991. New management of corporate communications/employee communications re-analyzed all their print and video projects.

According to Don Blank, Director of Operations, Georgia-Pacific Television, "The program covers general company news. It's a *PM Magazine* news magazine-type format. All the wraparounds in the *PM Magazine* format with the talent were done at G-P locations. One time we did wraparounds on a G-P sailing ship.

"One or two stories are light entertainment about G-P activities. For example, we had some employees that were in dog sled racing. We had a bunch of employees who built a plywood submarine for the Plywood Submarine Races that were held in Florida that *National Geographic* covered.

"Then there is at least one major, feature informational story. That can range from financial information (if it was quarterly report time or year-end financial figures), or a big acquisition, or a major plant expansion (e.g., a new machine going in) or a new marketing plan.

"Then there is a secondary shorter main story. If there was time in the episode, we might put in some news updates or "here's what's going on.""

"We try to hold each program to 20 minutes. Occasionally they drift to 24-25 minutes.

"Everything in the show was kind of news oriented. It might not have been today's hot news, it might have been news that had occurred in the last two months that the employee hadn't gotten any in-depth information about. Or maybe the employee did know about it, but here's some video interpretation of it."

Blank feels the style of the production is what makes the award-winning program effective: "I know that the style of production on the entire series—the graphic treatment, the way the talent was handled for the wraparounds, the feature story production techniques that went into each story, whether they were light or heavy stories—was essentially network quality.

"What made it network quality was camera work, editing, use of music, use of talent, graphics, animation. A lot of the people here have a broadcast background. Because our video operation runs as a profit center we market our services to the outside. So we are working in broadcast programming for cable companies and networks, we're also working in commercial production, national and regional television commercials, we're working in very high style, image videos for companies all around the country, as well as very basic corporate video for other people. So we have very broad exposure and because of that type of work I have been able to attract top people."

Blank offers two pieces of advice for producers involved in employee news programming: "The first and most important thing you need to do in a program like this is to communicate information that the people either need to know or want to know or both.

"If you just load it up with a bunch of fluff stories about fun things, if you orient it like a *PM Magazine* or *Entertainment Tonight,* corporate employees get plenty of that at home. They are watching your video because they *do* want information about what's going on in your company.

"In our case, and I'm sure this applies to a lot of companies, we are multi-divisioned. The guys out in the Building Products Division want to

know a lot about what's going on in their division that's not happening in their general area. They also want to know what's going on in the Paper Division because they don't know anything about the Paper Division. They have no exposure to that, so they're really interested. The same thing happens in reverse.

"I don't care how much production value and style and pizazz you put into it, if you're not giving the information these people want to have and don't stay on top of knowing what they want to have, your program will fail because nobody will be interested in it."

"My second piece of advice is: If you can afford it and have the facilities (or the money to buy it on the outside), the more broadcast production style you put into the show, the better it will be received. You are, indeed, competing for the attention of people who watch broadcast television. The more style you put into a show the better accepted it is, and the better accepted it is the better the retention of the information that you're trying to communicate."

PROGRAM DEVELOPMENT GUIDELINES

Users have indicated 12 general rules for using videotape for employee news as follows:

The employee news show must be viewed in the larger context of overall employee communications

Just as no one communications medium can help solve all communications problems, so too a TV news show cannot solve all employee communications problems. Before management decides to produce a TV employee news show, it must first define its overall employee communications objectives.

There are various ways managers can help solve communication problems: the print house organ, bulletins, personal letters, periodic meetings, social activities and so on. The question is: Is there a need to communicate via television?

There is no substitute for personal contact but it is not always possible. Print, the mainstay of employee communications, has distribution advantages. The employee house organ, for example, can be

distributed to all employees individually. So what will television add to the employee communications effort?

Television can add personality, a sense of immediacy, and timeliness. For example, in one company when the chairman of the board and the president appeared on the news shows, several employees stated this was the first time they had ever seen top management! Television, as opposed to print and film, provides the viewer with a sense of being there. It can also be timely. Perhaps one of the best examples was when Chase Manhattan Bank introduced a new president. The in-house video crew taped the news conference, edited the material that night and distributed the edited program the next day.

Video is a visual medium and can give depth to graphics that print cannot do. Video also provides a more "live" experience for the viewer than print. For example, the excitement of an intramural baseball game is much better conveyed on video than in print.

In sum, video can make company people, places, and events come "alive." Video news can contribute to employee morale and understanding of the corporation as a total entity. These communications programs can be defined in terms of objectives, audiences, and desired results.

The television program that will defy hard, quantitative analysis is the television employee news show. I am suggesting that it be the last application of video as a communications medium in the corporate context, not the first, because of the difficulty of measuring results and proving to management a direct return on investment.

The employee news show should be the last application of video as a communications tool, not the first

I have suggested above that management first take a look at overall employee communications problems and objectives when considering using television as an employee communications tool. This broad view can be put into an even larger context of the broad communications problems of the corporation, such as marketing and sales, external communications, training and management communications.

The point is that television is not merely the tool of public relations, or corporate communications, or personnel, training or marketing.

Television and its programming is a corporate-wide resource, similar to telecommunications and computer processing.

Moreover, television can be an expensive medium at first blush and should therefore be viewed in as large an "applications" context as possible. Employee news programming has great merit but it alone will not sustain the capital and operating expense required.

Define the objectives of the program

If video is going to be used for employee news communications, the program should have a well-defined set of objectives. Will it be used to: "improve employee perceptions" of company benefits; keep them "informed" of government regulations affecting the company's activities; "enhance employee understanding" of the various facets of the company's operations; "show" employees how the company provides advancement opportunities; or to "announce" major policy changes, salary increases, new activities, new products or how the company baseball team won the intramural championship?

Of course, all these objectives could apply. But management must also define when it will know that the news show has achieved even a modicum of success. Will it be the number of viewers? Will it be via feedback mechanisms such as questionnaires distributed on a periodic basis? Will it be the look on employees' faces as they watch themselves or their co-workers on the tube? Whatever the method of measurement, management must make clear what it expects from the program and how it is going to measure success or failure.

Producing a television employee news show is a full-time job. Hire someone who knows what he or she is doing

An employee news show is perhaps the most difficult corporate network programming to produce. There are several reasons for this. Very often events do not occur on schedule, or a segment will be scripted after the fact, or executives or employees are not available when the production crew is available. In many instances, corporate television employee news production crews have all the same problems commercial electronic journalism crews have. The scale of content and logistics may be different, but the central problems are all the same.

Look for someone inside the organization to act as a producer, hire someone from the outside who has experience in this area, or hire a consultant to train the in-house producer (if necessary).

Familiarity with the organization is crucial to producing a news show. You need to know whom to see, what to say and what not to say, and where to go for help.

Creating an employee news program on a weekly, monthly, or even quarterly basis requires a high level of concentration and focus. It will be the rare individual who can write for the print house organ one minute and produce and write for the electronic house organ the next. Hire someone who will work on this corporate television program full-time and you'll get the results required.

Define the programming mix before you start producing

There is a myriad of content possibilities for an employee news show: company benefits, department profiles, personality profiles, company involvement in community affairs, management policy statements, preventive health care segments, the company bond drive, United Fund announcements, driver safety, income tax tips, and so on.

Esoteric program segments won't go over very well. As one user put it ". . . stories designed for a general audience receive the greatest recognition." Whatever the "content" mix, the major criterion for the selection of stories is that they support the program's objectives.

Develop a production style that squares with the program mix

There are a variety of production styles and formats for an employee news show: news stories, features, entertainment segments, man-on-the-street interviews, graphics, titles, music, on-location material, in-studio material. Whatever the choice of style, it must fit the program's objectives and content.

There are several "core rules" about production style that do seem to apply. One rule is that only those stories that are well suited to television coverage should be included in the program. This implies that the program segment, in addition to concentrating on people, should concentrate on the activity being covered. Employee news, like marketing and sales, is a close application to broadcast television, and broadcast television highlights "action."

This kind of program should be produced with as much quality as possible. Because the application resembles "electronic journalism," there will be a tendency on the part of audiences to unconsciously expect a "broadcast" quality feel. This does not mean the production style of *NBC News* should be imitated. What is important is that whatever the content of the program, the available equipment and staff, every attempt should be made to strive for the highest quality possible—in scripting, videography, editing, etc.

In my experience, the employee news show is the hardest corporate video application to succeed with. Results are hard to measure. Content and production styles are hard to define. Be wary.

A corporate version of Walter Cronkite or Barbara Walters do not belong on a corporate television employee news show

Do not try to imitate the commercial electronic journalists, with a studio setting, an anchorman and broadcast news commentator style.

In my experience, it does not work. The style of the program should reflect the general style and environment of the corporate culture. Use that style and environment. It will be more credible.

Keep the program length to no more than 10 minutes

Employees do not have much time to view a corporate news program. Since viewing is not mandatory, the length of the show will have an effect on the survivability of the program. The length of the program will also affect its cost.

The basic rule of thumb: shorter is probably better than longer.

Base hardware needs on programming mix decisions

Too many companies have made the classic mistake of buying video production hardware before they had determined what their software needs were. This is especially relevant for employee news.

An employee news show is most effective when it is shot on location, as opposed to shooting in a television studio. Portable equipment is available, so there is really no strong need to shoot an employee news show primarily in a studio.

The decision to purchase production and post-production equipment depends on the volume of employee news shows to be produced, how many other kinds of video programs are or will be produced and the availability of external production and post-production facilities. Other than for reasons of security, if a company is producing less than 12 programs a year, external resources are more cost-efficient. Beyond 12 programs, it may pay to purchase production equipment but edit at an outside facility. Beyond 25 to 30 programs per year, it may be time to invest in a modest editing system.

Provide an adequate distribution system

Once you know who your audience is and where they are, you will need enough television monitors and playback units to reach them. Without an adequate distribution system, you will not reach your intended audience.

Television employee news shows differ sharply from print house organs in this respect. With the print house organ, the printed document goes directly to the employee, either to the desk or to the home. With the television employee news show, the employee has to go to the program. (Even though some companies use cable television to get to the employee at home, there is no guarantee that the employee will "receive" the program.)

With this inherent distribution problem, employee news shows should be given adequate publicity to let the employees know what will be on the show and where they can view it.

The cost of the employee news show should reflect its objectives

Keep things in context. If the objective of the employee news program is to have it viewed by all 30,000 or 100,000 employees every quarter, then an expenditure of $50,000-$75,000 per 20-minute program may not be excessive. On the other hand, if the program is to be viewed every week by corporate headquarters personnel only, then the cost of the programming should be lower. The difference between the two programs will likely be in the kind of content covered and where the segments will be shot. For a corporate-wide program travel for the sake of production will probably be the order of the day. For a headquarters-only program, the production requirements will be significantly different.

Sophisticated production editing techniques may be required and this usually translates into more production dollars. Rule of thumb: the further the audience from corporate headquarters and the deeper into the organizational hierarchy the program is distributed, the more sophisticated production and editing techniques required.

If the company is located in a big city, television employee news shows may not work

Employee news shows do not seem to survive in a big city, like New York; employees in the Big Apple are provided with too many distractions, such as shops and restaurants. However, in smaller communities there is less distraction from the outside during the work day which gives the television employees news show a greater opportunity to have a viewership.

SUMMARY

The television employee news show has been around since the early 1970s. And while there have been failures along the way, employee news remains a viable corporate programming network application.

Communicating effectively with employees is one of the more pressing problems facing today's corporate manager. Employees are more sophisticated, more discriminating, and less homogeneous. They are more concerned with the quality of their work lives.

Corporate communicators have their work cut out for them. The job will not get easier, it will become more challenging. If used judiciously, intelligently and rationally, employee news programming distributed via corporate television networks can be an effective and efficient means of contributing to successful management-employee communications.

11

External Communications: Reaching Out

Perhaps because of a confluence of technological developments (cable television, satellite communications, home video reaching critical mass), in the 1980s corporate communicators extended their use of the videotape medium beyond marketing and sales audiences to *external* audiences.

External communications includes the use of video for community relations, investor relations, public affairs, press relations and government relations. Little has been reported in either the trade or consumer press on the use of videotape for external communications in the corporate communications context. Industry studies published in 1986 and 1988 reflect the "apparent" modest use of videotape for external communications purposes.

For example, in the 1986 study, out of 20 programming categories, community relations, government/labor relations and security analysts relations were ranked 13th, 19th and 20th, respectively. However, the 1988 corporate video industry study reports ". . . more and more video

programming is being aimed at outside audiences such as customers, community groups and the general public."

Corporate network video programmers have a variety of distribution channels to reach external audiences:

- one-on-one with a community relations leader, government official or securities analyst
- via cable channels into select communities
- via local television outlets using video news releases (VNRs)
- or via home video networks

THE BENEFITS OF VIDEO FOR EXTERNAL COMMUNICATIONS

Since the early 1980s, corporate network programmers have given one central reason for the use of the medium for external communications: videotape is communications-effective. Producers have indicated that corporate dimensions—such as executives in action, growth trends, production operations and product demonstrations—can be presented far more clearly on television. Partly because we are so conditioned to television, there are things you can show more graphically in motion than in print.

Programmers have also stated that videotape makes company people real: "There's always a suspicion that the people in the printed report are actors." One producer said: "Video provided a realism that audiences could feel."

Still other programmers have indicated that videotape presents huge savings when compared to a print counterpart and that the speed of duplication provides for effective and efficient access to specific audiences.

INVESTOR RELATIONS

The first reported use of videotape for external communications purposes occurred in 1980. In that year the Emhart Corporation, headquartered in Connecticut, used the medium (together with satellite and cable television) for stockholder relations. The company reported it beamed the annual meeting video by satellite to 100 communities in eight states. It estimated reaching at least 2,000 of its 28,000 stockholders out of a total audience of 1.1 million. Emhart also reported

shareholders could borrow a tape to ". . . play on their home videocassette machines."

The application caused quite a stir and there was much talk in corporate television and public relations circles that this so-called "innovative" programming application would be widely adopted. There was also much talk (and some activity) in the 1980s about using "cable access" channels for the distribution of internal and external programming to reach customers, the community at large, and employees as well.

In retrospect, the use of cable television for these corporate television programming applications has been given more credence in the breach than in actual practice. There are some companies, both large and small, using cable access channels for the distribution of programming. But the use of satellite and cable technology for the distribution of "annual meeting" programming in the hopes of reaching a majority of stockholders is an occasional event.

PRESS RELATIONS

CBS has used videotape to promote its fall programming lineup to the advertising community. Disney's press relations department provided pre-produced videotapes for members of the press for the theme park's fifteenth anniversary celebration. The local United Way campaign in Appleton, WI used videotape to help with fundraising activities.

THE VIDEO NEWS RELEASE

Numerous companies are using videotape for the creation of VNRs, or video news releases. VNRs are 90 to 120 second stories that provide useful "public" information but incorporate a reference to a company's product or service. The VNR serves several mutual purposes. On the one hand, it provides local television news programmers with soft news segments that can sometimes be localized. For the corporate programmer it is a way to generate some public relations for the company's product or service on a national or regional scale. If handled properly, the VNR can be tied into an overall public relations/marketing campaign for the product or service. According to Eugene Secunda, media consultant and professor of marketing at Bernard M. Baruch College, over 5,000 VNRs are being generated annually by local or national organizations.

CONSUMER RELATIONS

The distribution channel that has also turned corporations on with respect to external audiences is home video. According to A. C. Nielsen, as of the end of 1991 VCRs are present in 73% television households in the United States.

The home video environment is a natural outlet for corporate external communications programming. Corporations are using the home video networks to market product demonstration programs and financial information programs. In some cases, companies produce a community relations video and distribute it internally, as well as on selected cable access channels and to certain homes in a particular community.

I do not think that external communications programming will see explosive growth in the next few years. There will be more of it. The use of video for *external customer marketing and sales* will see more growth than the use of video for community, government, investor and security analysts relations.

CASE STUDIES

Community Relations: Prodigy

Prodigy Services Computer Network (the IBM/Sears consortium) produced a 5-minute community relations video to demonstrate its interactive product in an unusual way. "The Generation Gap . . . Break It" tells the story of a Minneapolis sixth grade teacher who encourages his students to communicate with senior citizens via telecommunications.

According to program producer/director Jim Shasky, "The story shows how telecommunications, using the Prodigy system, can benefit kids. The Prodigy people said, 'Kids don't often stop and talk to older people because they're afraid of them. They think older people don't want to be bothered. So what better way to write to them than on a computer.' "

Through the comments of the teacher, the program describes how the students in this class communicated with residents of retirement homes. Says Shasky, "One of the kids asked a question of one resident saying, 'My mom and dad are divorced. I cry all the time. What should I do?'

One of the older people responded, 'Well, I love you, I'll hug you.' Real personal stuff. It's amazing what happens when you write to people and you don't see their faces."

Pre-production for this video took a little over a week, shooting a day and a half. There's no voiceover. The name Prodigy never appears in the program until the very end.

Prodigy distributed information on the program to several school administrators and teachers around the country. The program's message is how telecommunications can work: how it can foster communication among students, and communication between the generations.

What makes this ITVA award-winning program work? According to Shasky, "First you have to get a good production company. You've got to work with someone who knows television. Do your research. Don't spend a lot of money on days and days of shooting. My time is spent on pre-production . . . knowing exactly what I want when I go in there.

"Then you've got to find the story. As soon as I heard that there was this teacher using computers for communicating with senior citizens, I wanted to meet him. It turned out this was an award winning educator. As soon as I talked to him I knew he would be great on camera.

"I also work with a cameraman who is an editor . . . a great storyteller. Editing is a very intimate thing. You spend 12-15 hours a day in an offline suite, you had better be working with someone you like and who knows how to edit good stories. We've worked on a lot of projects together. Together we make high tech companies warm."

Shasky also believes that anyone who watches educational television, anyone who watches a monitor expects network quality. "Consciously or not they want entertainment," he says, "and they expect network quality."

Community Relations: Metro Toronto Community Services

Video is especially effective for communicating the impact of social problems. "No Day At The Beach," a 14-minute award-winning program on AIDS produced by the nonprofit Metro Toronto Community Services, is just such a program. The program received top programming honors from the ITVA.

Paul Downey, Manager of the Media and Communications Unit for Metro Toronto Community Services (Canada) explains: " 'No Day at the Beach' attempts to sensitize to people how it feels to have AIDS. It's not only a fatal disease, but carries a lot of stigma with it.

"We wanted dispel the stereotype that this is a gay disease or that only gays are getting it. An actress was used in the program because a lot of people who are hemophiliacs have gotten AIDS through blood transfusions. We didn't want to make the video homophobic or just present drug users and get involved with a lot of issues that weren't necessarily relevant to the subject."

The 1989 program—distributed to 30,000 government and agency employees in the Toronto metropolitan area—has been shown for over a year and is used in conjunction with a training tape and seminar.

Says Downey: " 'No Day at The Beach' is about how it feels to get AIDS: How are you going to tell your mother? How are you going to tell the people at work? When you're out from work for a long period of time there is a point where you have to explain to somebody what's going on and that means communicating confidential information."

Metro Toronto is apparently the first municipality in North America to come up with an employee policy on AIDS. The video was created as part of that policy. At one of the work sites in 1986 a worker gave mouth-to-mouth resuscitation to a person whom he thought had AIDS. The other workers were frightened by this incident and there was a work stoppage. The problem was sorted out through an educational process (bringing in medical opinions and doctors). The video was created to educate people about the policy in conjunction with half-day and three-day long seminars.

What made this $10,000 production an award winning program? Downey says it was the dramatization: "It was very fearful. People got the real uncomfortable feeling that 'it could be me'. It was quite emotional. People came away from seeing the tape with tears in their eyes. When we switched on the lights it was silent for two or three minutes afterward.

"The director of photography was very good at lighting for effect. The setting was video verité. A woman who has AIDS phones the

Figure 7: "Energy Update 2001" exhibit for Cook Visitor Information Center (Bridgman, MI). Produced for American Electric Power (IN) by Lester Associates, West Nyack, NY. Videodisc production by Media Enterprises Inc., New York City. Photo courtesy Indiana Michigan Power Company.

occupational nurse at her workplace and eventually faces having to tell her mother about her disease. There were scenes on a desolate beach. It was simple but very effective." Downey's operation produces about 20 videos a year. With regard to other programs of this type he says: "You have to believe in what you're saying. Understand the material you're working with. Keep it simple. Don't do too much ADO. If it's human, it will carry itself."

PROGRAM DEVELOPMENT GUIDELINES

With virtually nothing in the trade or consumer press regarding the guidelines for using videotape in the external communications environment, what can be said about "rules of thumb" in this area?

Clearly, this programming category is akin to that of marketing and, more broadly speaking, to the television commercial: audiences are select in a sense, but in another sense audiences potentially can reach hundreds of thousands.

The guidelines articulated in other programming categories—such as defining objectives, audience profiles, audience environment, yardsticks for measurement, etc.—apply equally here.

Quality is the only rule that counts

Whatever the audience or environment, the quality of the product must be superior to any other corporate video application.

Let's take a look at the example cited earlier: the use of cable television to disseminate information to shareholders.

This programming was viewed in stockholders' "homes." Other than the use of video in a retail outlet environment, the home is perhaps the most media-competitive environment of all the contexts discussed. The programming is in direct competition with the very best broadcast and cable television Hollywood has to offer. It is in competition with the telephone, the newspaper, the radio, the home computer, video games, and every other activity that takes place in a home.

If the programming is not of the highest quality, it will not be watched. Moreover, if it is less than high quality, it will be regarded as irrelevant.

External communications programming can also be shown at a community meeting, in a government official's office, at a press conference, or a stockholder's meeting. Is the competition for attention in these other environments any less than the home environment? The answer is: no.

Of all the applications (with the exception of marketing/sales promotion), audiences for external communications programming have little if any vested interest in the programming—either the message, who is in it, or who is disseminating it. Therefore, the quality of the program must be of sufficiently high value to either catch an audience's eye (while the dial is being turned) or keep it if they stay tuned.

This applies to a program disseminated on cable television. In any other environment, the audience may be somewhat more captive. But because the vested interest level is so low, the quality must be high.

Promote, promote, promote

A communications program is meant to promote some aspect of the company to an external audience. However, in order to get the message across, you must first get the audience to the message. In the case of a cable television distributed program, this may mean local print advertising, radio spots, and community group support. For any other kind of external communications environment, information must be distributed ahead of time in order to get the right audience to the showing of the programming.

This is a case where one message is used to get an audience to the next message. Doing this may require a letter, a flyer, bulletin board notices, whatever it takes. Like it or not, a successful external communications program requires a touch of sales promotion and advertising for success.

12

A Look Back . . . A Look Ahead

WHERE HAVE WE BEEN?

In 1956 Ampex introduced a commercially viable quadraplex video-tape recorder using 2-inch-wide tape manufactured by 3M. The 900-pound machine was inaugurated at the National Association of Radio and Television Broadcasters (NARTB) Show in Chicago in April of that year.

This first prototype video recorder was shown to some 200 CBS-TV affiliates gathered at the NARTB. The videotape ran at a speed of 15 inches per second (ips) past a magnetic head assembly which rotated at a high rate of speed. The recorder was a bulky console with 14-inch reels.

It sold initially for $75,000 per unit and functioned only in black and white. In the ensuing four years, Ampex sold 600 videotape recorders, two-thirds of which were bought by the three major television networks.

THE NON-BROADCAST TELEVISION MARKET

By the late 1950s a handful of so-called "nonbroadcast" organizations had adopted the medium for a variety of programming purposes. Over the course of the last 35 years this handful has multiplied to tens of thousands.

A 1988 Knowledge Industry Publications, Inc. (KIPI) study reported 49,000 nonbroadcast users of videotape in the United States. It also reported the nonbroadcast television market generated $5.5 billion in sales in 1987, of which $3.5 billion was spent on programming. (In effect, the total nonbroadcast television market in 1987 was larger than movie box office sales in the same year!) For 1991, D/J Brush Associates report that corporate television is in the $6 billion + range.

Another indication of the growth and size of this market is the evolution of the International Television Association (ITVA), born in the early 1970s. (Prior to its formation there were two professional associations. As of 1968 the Industrial Television Society included video users in San Francisco, Chicago, Tulsa, Philadelphia and western New York State. In 1969 the National Industrial Television Association was founded with a similar membership in metropolitan New York City, Connecticut, New Jersey, Boston, Minnesota, Wisconsin and Dallas. These organizations merged in 1973 and created the International Industrial Television Association. The word "industrial" was ultimately dropped to reflect the adoption of the medium by "non-industrial" organizations.)

In 1973 ITVA membership was a little over 300. In 1991, membership in the United States and abroad was approximately 12,000.

To answer the question, "Where is the corporate television programming market going in the 1990s?" we shall take a brief look at the development of corporate television programming from the late 1950s to the present.

The Late 1950s–1960s

Videotape use in the late 1950s-1960s was comparatively centralized. This was primarily due to technical factors: the lack of equipment standards and portability.

A 1969 study by the American Management Association reported ". . . early equipment was large, nonportable and very expensive." However, "a steady stream of technical developments in fields such as solid state research and microcircuitry has cut away these obstacles. Current videotape equipment is compact, portable and reasonably priced. These sharply improved qualities have opened the way to scores of possible applications."

Dr. Thomas Stroh, the study's author, points to the technological problems of the 1960s: Many recorders did not play back tapes made on other machines—even those manufactured by the same company. He also observes that there were no industry standards for number of lines of picture resolution, the number of recording heads, the speed of the tape over the recording heads, and tape width. Further, there were serious problems with equipment servicing and few facilities for training new users in the field.

Sales Training

The first reported use of corporate video for sales training occurred in January 1959, when Buick conducted a 31-city closed-circuit telecast for dealer salesmen. A major reason for the use of the medium was videotape's "flexibility."

From the thousands of men who sold Buicks across the country, the company selected four for its telecast meeting. These were members of Buick Royal Purple Salesmasters, the elite of dealership salesmen. They became a panel, interviewed on the telecast to elicit their selling secrets. They also served as a sounding board for ideas put forth by other salesmen who were picked up by remote camera crews in dealer showrooms.

Sales and Marketing

On February 3, 1959, the Ford Tractor and Implement Division of the Ford Motor Company (Dearborn, Michigan) used videotape to demonstrate equipment on closed-circuit television for farm equipment dealers.

The demonstrations were made possible by the advent of the first completely self-contained mobile video unit built by Ampex. The

closed-circuit presentation originated out of NBC's studios in Hollywood, California. This was only the second time the mobile unit had been employed.

A major reason for the use of videotape was the instant playback feature. The farm equipment had been videotaped in operation in Yuma, Arizona. Had film been used and a sequence failed to turn out properly, the entire operation would have had to have been repeated a day or two later. The videotape medium allowed production personnel to play back shots and re-shoot immediately.

Skill Training

Videotape's use for skill training was first reported by 3M in 1960. With this application we began to see a broader use of the medium.

According to a 3M report, "New Channel for Learning," published in 1960:

> It was Tuesday. The time was shortly before 4:30 in the afternoon. Groups of employees began to congregate at six locations throughout their company where television receiving sets had been set up. The employees were armed with pencils, papers and workbooks as they settled themselves in before the monitors.
>
> Sharply at 4:30, the television beamed in clear with the sound of the announcer's voice identifying himself. He went on to inform the viewers that they were watching Channel 2, St. Paul/Minneapolis, the educational channel of the Twin Cities area. The program they were about to see was the first of a 12-week video-taped course in "Efficient Reading."

Role Playing

The first report of videotape's use as a role playing tool appears in the January 1966 issue of *Training in Business and Industry*. In the article, the author states, "The Institute—GM's central training agency—initiated television playback in the fall of 1964"—eight years after the introduction of commercially viable videotape and magnetic recording technology.

The 1970s: Corporate Networks Are Born

By the early 1970s, there is a major shift in the use of videotape. Distribution of videotape messages moves from "highly centralized" to "decentralized." The era of "corporate networks" is born along with so-called broad application programming, like "general employee communications" and "employee news."

The explosion of corporate video networks in the early 1970s was precipitated by the commercial introduction of the 3/4-inch U-Matic videocassette by Sony in 1971, and the 1/2-inch Beta and VHS formats in the mid 1970s.

This made videotape truly "accessible." The format was standardized among manufacturers. It was easy to use. No engineer was required. It was light and portable.

Along with developments in videotape technology, cameras got lighter. As a result, field (versus studio) production became even more accessible. Computer editing (with SMPTE timecode), computer graphics, animation stands, and personal computers (for scriptwriting and other purposes) combined to spur corporate programming applications and the growth of corporate networks.

Issues of technology standardization and portability, similar to those found in the 1969 Stroh study, crop up in a 1974 report as well. *Private Television Communications: A Report to Management,* published by Knowledge Industry Publications, Inc. (White Plains, New York). For example, the authors point out that a lack of standardization and an excess of videotape formats were causing problems.

Even though five years elapsed between the 1969 Stroh and the 1974 KIPI studies, the latter reports that "sales training" in particular and "training" in general were still major uses of the videotape medium.

Growth can be seen in the number of programs being produced . . . at an average number of 27 per year per organization.

The 1969 Stroh study did not cover the number of viewing locations; the 1974 KIPI study does. Clearly the advent of the 3/4-inch videocassette created an efficient and effective means of creating corporate television networks.

A third study of the corporate television industry was published by the International Television Association in 1977. According to the authors, "Decentralization of video production is one of the major trends . . . In 1976 three-quarters of the respondents having in-house facilities shot some or all of their programs outside the studio. These users produced an average of 39 percent of their programs on location. Almost one-third shot more than 61 percent of their programs in the field."

This study found "Specific Job Training" to be the top ranked application. Once again, training was the dominant use of the medium with management communications and safety, direct sales, and security analyst presentations moving up a notch or two.

The broadening use of the medium is reflected in the number of programs being produced. While the 1974 study accounted for numbers of programs over 50, the 1976 study accounted for numbers of programs over 100.

Another major difference between the reports is the 1977 observation that users were distributing programs to "overseas" locations: 23.6% out of a total of 225 respondents were distributing programs overseas.

Top Management Gets Visible

General employee communications covers a broad area and includes policy announcements, changes in top management, benefits information, retirement information, employee orientation programming and management communications.

From the available evidence, it is clear top management had become very visible via videotape in the 1970s. In fact, top executives were not only a part of the video, but were also the "stars." This use of the medium seems to have satisfied a desire on the part of management to reach all employees, not only at headquarters but also in field locations in a short period of time after the creation of the program.

This application also indicated a production style break from highly structured training programs: many of the events videotaped were structured in some way, but not highly scripted.

Employee News

The use of videotape for employee news also reflects changes in videotape technology.

The earliest reported use of videotape for employee news is Smith Kline and French's (Philadelphia) news show, started in 1970. Despite this, the 1974 KIPI study does not have a category for employee news. The 1976 study ranks employee news as ninth highest, as does a 1979 KIPI study. A 1980 ITVA study ranks the category as sixteenth highest (out of twenty categories).

Videotape for employee news, according to the studies, seems to have enjoyed a period of considerable popularity, although in more recent years it has faded from fashion.

The 1980s: Reaching Out

The 1980s witnessed another significant shift. Corporations started to reach out and touch everyone with videotape technology-based messages: they used the medium for "external communications," such as sales promotion, community relations and general public relations.

This period also witnessed a growing use of satellite technology for "business television" purposes: point-to-point and multi-point "live" programming. Pretaped programming is folded into this form of television communications.

Knowledge Industry Publications conducted a survey, *Video in the 80s,* of the non-broadcast video industry in 1979 (published in 1980) that showed the industry (all segments) had grown dramatically. According to the survey, of the 27,000 nonbroadcast users in the United States, 13,500 were in business and industry. By the early 1980s about 53% of all business/industry respondents reported having networks of between one and 25 locations; nearly 16% had more than 100 locations.

A specific survey of the nonbroadcast corporate video industry (*Private Television Communications: Into the Eighties*) was conducted in 1980 and published in early 1981 by the International Television Association (ITVA). The results were fairly consistent with earlier studies: "training" was still one of the dominant uses of the medium.

Hi Press Inc. published an update of a 1986 study (*Private Television Communications/Update '88: September 1988*) in response not to technological changes per se, but changes in America's corporate topography, i.e., ". . . the effects that the current wave of mergers, acquisitions, takeovers, reorganizations and downsizings are having on corporate television."

Of the several effects, the authors mention that corporate television departments have increasingly become full charge back operations (contributing to the bottom line), independent profit centers (in some cases), divested into independent production companies, or cut back.

This 1988 survey indicated that for the first time an almost 30-year trend was in the process of being reversed. While training had been the mainstay of corporate television programming, general employee communications and certain external communications programming applications were becoming more dominant. As the authors put it: "In the past, training applications usually paid the freight and [general] communications went along for the ride. The ranking[s] . . . show that this situation is now becoming reversed. . . . we see more and more video programming being aimed at outside audiences such as customers, community groups and the general public."

This study reflects the continuing growth of distribution networks:

Growth Rate of Viewing Locations	
Year	Median Number of Viewing Locations
1973	8
1977	18
1981	34
1985	70
1988	113

Summary

The use of videotape has gone far beyond original expectations, both in the broadcast and non-broadcast contexts. But that is usually the case with new technologies.

In the early stages, a handful of individuals and organizations enthusiastically adopted the medium, while most others either could not afford it or were askance to try it; witness the controversy reported by Dr. Stroh in the 1960s. Even with the advent of the videocassette in the 1970s, there was still resistance to the medium in the corporate world. It has taken decades for the medium to become truly part of the "communications" landscape. Is there any organization today that does not take the VCR for granted?

In the 1990s television and videotape in the corporate context have become transparent. What has emerged in the last few years is a heavier emphasis on software and on programming.

TOWARD 2000: A LOOK AHEAD

The use of videotape in the corporate context has grown not only in terms of applications, but also in actual volume. However, should we take it for granted that the past is prologue?

Even cursory analysis indicates that videotape as a communications medium is far from being replaced by another medium. The growth of the use of satellites, for example, should spur the growth of various kinds of teleconferencing (audio only, audio enhanced, and video teleconferencing). But it is unlikely in this decade that teleconferencing will cause a displacement of the use of videotape. It is more likely that teleconferencing will provide corporate programming opportunities that did not exist before, such as the use of videotaped programming as part of the teleconference.

And the video disc? In the early 1980s it looked as if the video disc would provide a challenge to videotape. But the performance of this new medium so far has been troublesome. Production on video disc is tedious and lengthy. Moreover, the ability to record and play back material immediately has not yet been commercialized, although it is technically possible. And manufacturers are deeply committed to videotape technology.

It is unlikely that the video disc will supplant videotape as a communications medium in the corporate context within this decade. But with developments in video CDs together with multimedia technology, it is likely this kind of interactive media will have made significant inroads by the year 2000.

What about the future of corporate video operations? What does the future hold for corporate video professionals? How will the corporate video operation evolve?

The history of corporate video operations indicates that there has been a general consolidation of corporate video operations into personnel/training departments and, more recently, into corporate communications departments. The marketing department is no longer a primary place for the corporate video operation, even though its use of the medium is growing.

Some contend the video operation belongs in the corporate communications department because of the broad view that department has of the corporation. My own view, presented in *Managing Corporate Media* (Knowledge Industry Publications Inc., 1989), is that the video operation belongs, at the very least, in a neutral department not tied to any communications content; i.e., a general services department.

Will either of these contentions apply to the future? It seems obvious there are four areas where corporate video practitioners could and should become more involved in the years ahead: teleconferencing, multimedia, cable television and home video.

Why teleconferencing? In a short time, more and more organizations will use teleconferencing (or "business television") for a variety of communications purposes. Corporate video practitioners have already developed an expertise in video production; a teleconferencing environment, particularly one involving full-motion video, is an extension of that expertise.

Why cable television? Cable television presents various opportunities for corporate and marketing communications. These opportunities will be explored by a growing number of organizations as the ability to communicate with local and regional consumers becomes feasible with the growth of cable and as the need to supplant national advertising locally and regionally gains support with advertisers. The more professional video operations will have an opportunity to create programming for cable television outlets.

Why home video? The home video market is hot. It has grown substantially in a very short period of time. Seventy-three percent of the television households in the United States have at least one VCR. These

VCRs should be viewed as additional/incremental distribution outlets for corporate marketing and public relations programming. The home environment is a natural extension of a company's marketing and public relations activities.

These opportunities notwithstanding, it is my view that in the next few years various in-house video operations will go under, primarily because of economic factors and an increasing demand for professionalism by organizational management on the other.

Marginal operations will cease. Demands for productivity—i.e., effective programming—will be prevalent. Clients will become more savvy, they will become younger, a whole crop of middle managers will move up the ranks to top management in the 1990s and they will understand what video is about. They will not regard video as a toy. They will see it as a tool and it better work. Those that manage video functions or produce the programming had better know their business.

The future organizational place of corporate video functions is not as clear. Various scenarios are possible. One scenario is, of course, that personnel/training and corporate communications departments will remain the two focal points for video operations. Another scenario could see the amalgamation of video operations with telecommunications or office technology and information processing. Idealistically, organizations might move towards the development of macro-communications departments reporting directly to the company's chief operating officer. Such a scenario is possible, but not very probable given the politics involved in evolving such a department.

Where corporate video operations will be organized is dependent to some degree on the people managing it. Again, it will be a matter of attitude: if video is perceived as a communications tool that cuts across all organizational lines and that concept is "marketed" to the organization, then the corporate video operation will end up in an organizational status that reflects its potential. If the view is narrower, the video operation will remain in a narrowly focused department.

The impact on the promotability of corporate video operation personnel and salary structures is obvious. The more global the view of the operation, the better the opportunities for advancement and compensation. The future of the corporate video profession belongs to those who look beyond next week's production schedule or next year's

budget. The future belongs to those who have the vision to see the potential of the medium and the courage to push back the barriers sometimes imposed by organizations. The future holds much promise for those who prepare for it. Those who don't will not be in the business for long.

The corporate video profession has moved a long way from the late 1950s. Applications have broadened and for the most part so too have the people in the business. Unfortunately, technological as well as societal developments do not allow much time for a breather. Other electrovisual technologies are developing. A world economy is becoming more readily apparent. Global communications systems are evolving. A counter-thrust to this globalness is the advent of regional and local concerns over and above national and even international concerns. It seems the more globally interactive the world becomes, the more we are concerned with affairs right in our own backyard.

All these thrusts will affect the corporate environment in terms of products, markets, financing, production, staffing, and organization. In turn, these factors will affect corporate communications and thus corporate television programming.

These changes will test even the best of the corporate television professionals. It will be a demanding decade . . . and potentially rewarding.

Appendix A

The Electrovisual Manager: A Summary

SENDERS AND RECEIVERS

Corporate television programming for internal and external corporate communications in the United States has been characterized by *management* use: top management, corporate staff management and line division management. With corporate staff management the heaviest user, videotape is, far and away, a *corporate staff* management communications tool. Over the last three-plus decades, approximately three-quarters of the time corporate staff managers have initiated the use of the medium:

INITIATION OF CORPORATE VIDEO	
• Corporate Staff Management	77%
• Line Division Management	16%
• Top Management	9%

In the corporate context, videotape is *not* a mass communications medium, but rather a narrowcast medium, i.e., the vast majority of audiences for videotaped information are highly select, whether internal or external publics, as follows:

AUDIENCES FOR CORPORATE VIDEO

• Select employees company-wide	57%
• Select external publics	15%
• All employees company-wide	10%
• All employees at corporate headquarters	9%
• All external publics	6%
• Select employees at corporate headquarters	3%

The location of audiences confirms the above observation. Since 1959, the number of decentralized audiences vs. centralized audiences has remained fairly even, as follows:

AUDIENCE LOCATIONS

• Decentralized audience at multiple locations	52%
• Centralized audience at corporate headquarters	31%
• Centralized audience at regional centers	15%
• Decentralized audience at corporate headquarters	2%

REASONS FOR USE

Corporate television programmers have collectively articulated over a dozen reasons why videotape in the corporate communications context works, in the rank order shown on p. 169.

Communications effectiveness is *the* major reason managers and producers use videotape. And when we combine the first two reasons, it becomes even more clear that it is the "communications" impact of the videotape medium that makes it attractive.

The second central reason rests on the technology itself—video can reach decentralized audiences, it is efficient and flexible to use for

production, it is self-instruction capable and there is fast turnaround from production to distribution.

REASONS WHY VIDEOTAPE WORKS

- Communications effective
- More effective than film and print
- Can reach decentralized audiences
- Cost-effective
- Efficient and flexible to use for production
- Training uniformity
- Can simulate reality
- Allows trainee participation
- Can manipulate real time-real life
- Extends the subject expert
- Saves time
- Improves employee morale
- Fast turnaround from production to distribution
- Extends corporate advertising

What seems to concern corporate television programmers most is the communications impact of the medium once it gets to its audience, and secondarily, the relative ease of getting that information to the audience.

THE PHYSICAL VIEWING ENVIRONMENT

Corporate television programmers describe four types of viewing environments across all categories. There are two kinds of physical environments: fixed and portable.

VIEWING ENVIRONMENT

• Special viewing rooms	43%
• Routine meeting rooms with portable viewing equipment	30%
• Outside meeting rooms with portable viewing equipment	19%
• In the home on the home television set	8%

The fixed viewing environments are those represented by "special viewing rooms" and the "home environment." The portable viewing environments are represented by "routine meeting rooms" and "outside meeting rooms."

In a period of 30+ years, videotape has moved out from the sales training/role playing environment into practically any place where people congregate, from the office to the home.

PROGRAMMING GUIDELINES: A SUMMARY

Corporate television programmers have articulated 21 overall guidelines regarding the development of programming for corporate television networks.

These guidelines can be divided into two major groups: (1) creation of the program, and (2) the communications environment once the program is distributed.

Many of the principles in the latter category concern the use of videotape for role playing purposes, one of the earliest uses of the medium in the corporate communications. Second, prior to 1971, users were concerned with program style and techniques, content styles and use of the program in the field. Since 1971, however, there is a dramatic increase in concern for the use of professionals and non-professionals, program length, research/script preparation, in addition to an increased concern with production style and techniques.

The implication is that technology developments in 1971 and since allowed for more control of the presentation of the content. As the technology developed from a highly "unportable" technology to a "portable" one with the ability to reach diverse audiences at multi-locations, corporate television programmers have become more and more concerned with the stylistic aspects of the medium, rather than specific technological aspects.

PRODUCTION CONCERNS

Program styles and techniques
Use of professionals/non-professionals
Content styles
Research/script preparation
Program length
Equipment considerations
Choice of media
Field vs. studio production
Editing/pacing
Production staff
Production costs
Technological effectiveness

COMMUNICATIONS ENVIRONMENT

Use of program in the field
Use of pre-recorded tapes
Size of the role play group
Role play tape review
Procedures
Role of the training staff
Diffusing student anxiety
Length of role play sessions
Measuring effectiveness

Appendix B

Major Studies of the Corporate Television Industry

1. Stroh, Thomas F. *The Use of Video Tape in Training and Development*. New York: American Management Association, 1969.

2. Brush, Judith M., and Douglas P. Brush. *Private Television Communications: A Report to Management*. White Plains, N.Y.: Knowledge Industry Publications Inc., 1974.

3. Brush, Judith M., and Douglas P. Brush. *Private Television Communications: An Awakening Giant*. New Providence N.J.: International Television Association, 1977.

4. Dranov, Paula, Louise Moore, and Adrienne Hickey. *Video in the 80s*. White Plains, N.Y.: Knowledge Industry Publications Inc., 1980.

5. Brush, Judith M., and Douglas P. Brush. *Private Television Communications: Into the Eighties*—The Third Brush Report. New Providence, N.J.: International Television Association, 1981.

6. Brush, Judith M., and Douglas P. Brush. *Private Television Communications: The New Directions*—The Fourth Brush Report. Cold Spring, N.Y.: H.I. Press of Cold Spring, in association with the International Television Association, 1986.

7. Stokes, Judith T., *The Business of Nonbroadcast Television*. White Plains, N.Y.: Knowledge Industry Publications, Inc., 1988.

8. Brush, Judith M., and Douglas P. Brush. *Private Television Communications: The Fourth Brush Report, Update '88*. LaGrangeville, N.Y.: H.I. Press, 1988.

About the Author

Eugene Marlow has been involved with media for over 25 years—as a stage, film and television producer/director, scriptwriter, marionetteer, stage manager, radio producer and announcer, author, musician and composer, and educator.

He is a consultant specializing in the use of print and electronic media for marketing, public relations and corporate communications. He teaches electronic journalism and business communication at Bernard M. Baruch College (City University of New York).

In the last 20 years he has produced over 500 video, radio, multi-image, videodisc and teleconferencing presentations. Mr. Marlow has received dozens of awards for programming excellence from a variety of national and international organizations, including the Chicago Film Festival, the Council on International Non-Theatrical Events, the International Film & Television Festival of New York, the Quasar Awards, the Telly Awards, the Society for Technical Communication and the International Television Association.

Between 1972-1982, Mr. Marlow held executive media production positions with Citibank, Prudential Insurance and Union Carbide

Corporation. As Manager/Corporate Video Communications with Union Carbide, he expanded the company's embryonic worldwide video network and designed and implemented a $2 million media production facility. His department received Audio Visual Department of the Year honors from the Information Film Producers Association in 1982.

He is co-author of *Shifting Time & Space: The Story of Videotape* (Praeger, 1991), and author of *Managing Corporate Media* (2nd Edition, (Knowledge Industry Publications, Inc., 1989) and *Communications and the Corporation* (United Business Publications, 1978).

He is a contributing author to *The Teleconferencing Handbook* (Knowledge Industry Publications Inc., 1983), *Video Production Techniques* (Corporate Video, London, England/1983) and *The Video Handbook* (United Business Publications, 1977).

Since 1974 he has published 75 + articles on television programming and video technologies in the United States and Europe in: *Backstage, Cable Television Business, Educational Broadcasting, Educational & Industrial Television, In-Motion Magazine, Industrial Marketing, International Television Magazine, Madison Avenue Magazine, Post Magazine, PRSA Journal, Sales & Marketing Management, The NATPE Programmer, Video Manager, Video Pro, Videography* and *View Magazine.*

Prior to his involvement in the electronic media field, Mr. Marlow was an award-winning Vietnam War historian and news editor for a mass merchandising trade journal.

Mr. Marlow founded and chaired the New York Chapter of the International Television Association in the mid-1970s and later served as its National Director of Professional Development.

Mr. Marlow earned a Ph.D. in media studies from New York University and an MBA from Golden Gate College.